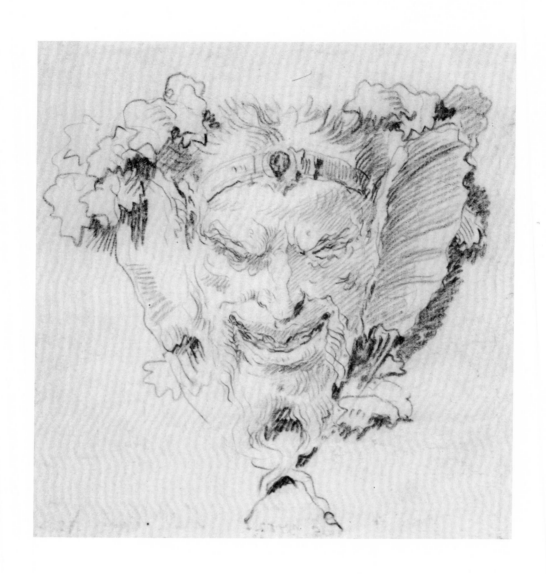

The Mask of Venice

MASKING, THEATER, & IDENTITY
IN THE ART OF TIEPOLO & HIS TIME

Edited by

James Christen Steward

With essays by

George Knox and *James Christen Steward*

University of California
BERKELEY ART MUSEUM
IN ASSOCIATION WITH THE UNIVERSITY OF WASHINGTON PRESS

Published on the occasion of the exhibition *The Mask of Venice:*
Masking, Theater, and Identity in the Art of Tiepolo and His Time
organized by the University of California, Berkeley Art Museum,
11 December 1996 through 4 March 1997

Published 1996 by the University of California, Berkeley Art Museum

Distributed by the University of Washington Press,
P.O. Box 50096, Seattle, WA 98145

The photographs in this publication have been provided
by the owners or custodians of the works and are reproduced with
their permission. Additional photographic credits are noted below.

PHOTO CREDITS
Ben Blackwell, cat. nos. 2, 30, 31, 43–50, 56–61
Fine Arts Museums of San Francisco, cat. no. 67
David A. Loggie, figs. 16, 68
Lou Meluso, cat. no. 32
National Gallery of Art, Washington, © Board of Trustees, cat. no. 44
New York Public Library, cat. no. 11
Robert D. Rubic, cat. nos. 11, 12
David Tunick, Inc., cat. nos. 14, 33, 34
© Elke Walford, Hamburg, fig. 7

FRONTISPIECE: Cat. no. 52. After Giovanni Battista Tiepolo, *Satyr's Head*
PAGE 6: Cat. no. 16. Giovanni Battista Tiepolo, *Old Man Standing with Arms Folded*

Edited by Fronia W. Simpson
Designed by Christine Taylor
Produced by Wilsted & Taylor Publishing Services

Contents

Director's Foreword 7

Preface 9

Acknowledgments 11

Lenders to the Exhibition 13

Masks and Meanings in Tiepolo's Venice 15
James Christen Steward

The Private Art of the Tiepolos 35
George Knox

Catalogue 49

Select Bibliography 116

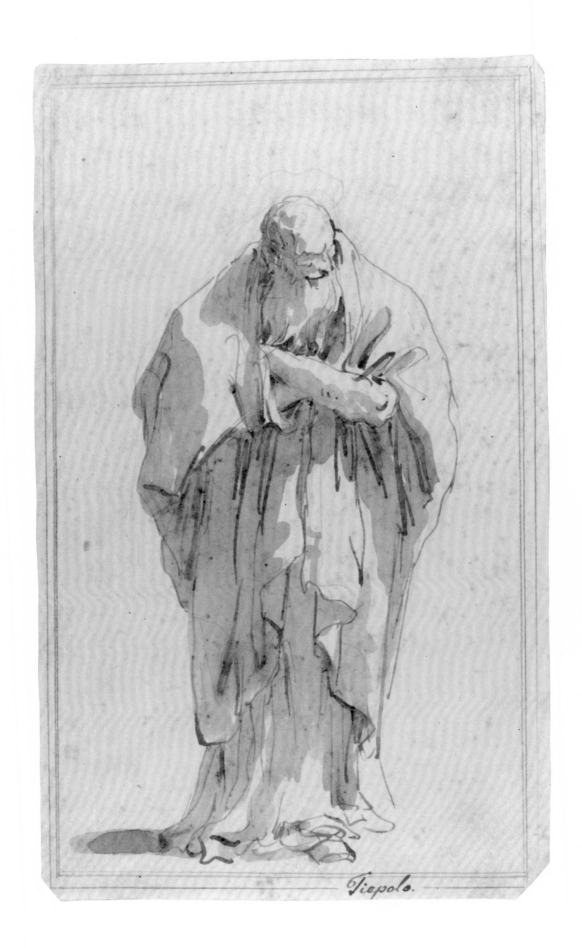

Tiepolo.

Director's Foreword

The Mask of Venice: Masking, Theater, and Identity in the Art of Tiepolo and His Time continues the tradition—now over twenty-five years strong—of presenting distinguished art exhibitions at the University of California, Berkeley, that are part of a larger project of cultural analysis. Our belief in the importance of the visual arts to our communal life leads us to make important works of art available to a broad public, while contributing to and stimulating ongoing scholarly debates within the academy. This exhibition fulfills the museum's commitment to historically wide-ranging exhibitions, a commitment that has been strongly reinforced since James Steward joined the museum's staff in 1992. *The Mask of Venice* is his second major exhibition at Berkeley devoted to the art of eighteenth-century Europe, a time of broad change and social questioning, a period with strong affinities to our own fin-de-siècle anxieties and introspection.

As its subtitle suggests, this exhibition is intended to move beyond a specific theme to pose the much wider question of how identity was construed in the visual arts during this time of intellectual and spiritual ferment. While the exhibition and its catalogue explore themes of strong resonance for a contemporary audience, they do not neglect the visual. *The Mask of Venice* provides an extraordinary opportunity to take a fresh look at the contributions of many of the great artists of eighteenth-century Venice, most notably that of Giambattista Tiepolo, whose three-hundredth birthday we celebrate. Although the collective contribution of these artists is by now well

documented, the present exhibition provides an all too rare opportunity to view here on the West Coast an extraordinary gathering of Venetian eighteenth-century art, while inviting us to look at the subject matter of Tiepolo and his contemporaries in a new light.

This project would not have been possible without the generosity of the lenders to the exhibition, a generosity of special note in regard to the many very fragile works on paper that have been made available to us. Further, the good support of the National Endowment for the Arts in making a major grant to the exhibition has been key to its success. We are also grateful to Bvlgari for its generosity in helping bring *The Mask of Venice* to the stage in Northern California, and to Professor and Mrs. Werner Z. Hirsch for graciously underwriting the cost of this catalogue. Mrs. Lewis Callaghan, Jane Restaino Green, and Barclay Simpson have provided both moral and financial support for this and other exhibitions of old-master art organized by James Steward. To these wonderful trustees of our institution, and to their colleagues, we owe a deep debt of thanks—the ongoing support and energetic commitment of our trustees to the goals of the University of California, Berkeley Art Museum and Pacific Film Archive are vital to the realization of exciting and worthy projects such as this.

Jacquelynn Baas, *Director*
University of California, Berkeley Art Museum

Preface

Giambattista Tiepolo is, by a general critical consensus that has emerged in the last thirty years, the most important artist to have come out of eighteenth-century Venice. In this anniversary year a number of exhibitions—notably major projects in New York, Cambridge, and Udine—examine his work. This exhibition clearly differs in important ways that perhaps require a word of explanation: it is not monographic, it does not include many of the artist's most bravura drawings, it does not include any of his paintings, nor is it especially international in its loans. The obvious question, then, is what it does.

The most immediate answer I would propose is that it seeks to place Giambattista in a wider social and visual context, one that speaks to the setting that propelled him and his highly idiosyncratic visual vocabulary. But I would like to come at a fuller answer by citing an anecdote from the early days of planning for this project. A noted Tiepolo scholar remarked to me that in many ways Giambattista is "unexhibitable" because subject matter is irrelevant to his work. He could and did paint or draw just about anything. In part out of stubbornness, I refused to let such a view get in the way of this project—and a thematic approach seemed necessary since we were not, after all, equipped to mount a major survey, nor did the need exist, since other projects being planned were to look at the questions of Tiepolo's artistic development and process. The comment instead provoked me to think further about the question of subject, and how we might define it in regard to Tiepolo's works on paper.

I have, as is clear from my selection of works, concluded that subject is vital in Tiepolo, and that the approach taken here—one that looks at the notion of the mask both literally and figuratively—ultimately reveals an important side to Giambattista's oeuvre. This notion of the mask suggests ways in which the artist's private production (and here I might usefully speak of Domenico's private output as well) hides but ultimately reveals. The oft-described mysteriousness of Giambattista's printmaking need not, therefore, intimidate us but can point to ways in which the subtle revealing of artistic identity becomes the subject of a great print series.

The second way in which I think such an approach can be useful is in bringing the print series before a wide, nonspecialist audience. Much as connoisseurs, collectors, and curators may admire the *Scherzi* and *Capricci*, the difficulty of approaching their subject suggests that another entrée is needed, the proverbial "hook" that suggests a relationship between the viewer today and a personal iconography that has puzzled the experts for over two hundred years. This is vital, just as it is vital for the Berkeley Art Museum to speak not only to its academic audience but also to a broader constituency drawn from, at the least, the entire San Francisco Bay Area. The words *Venice* and *mask* may evoke many meanings, but they have a good likelihood of making a connection among the unconverted where old-master prints in general, I fear, may not.

Finally, practical considerations have dictated that most of the works on view in Berkeley—indeed, all but one—should come from U.S. collections. Where possible, we have tried by preference to include works from California collections. It is our hope that the exhibition does not suffer from the necessary exclusions, which may in the end be entirely appropriate to a project that remains a workshop for ideas rather than a forum for conclusions.

James Christen Steward, *Curator*
University of California, Berkeley Art Museum

Acknowledgments

Despite sharing its locus in the eighteenth century with other projects I have developed at Berkeley, *The Mask of Venice* is a departure in some respects in being a truly collaborative venture. Indeed, the genesis of an exhibition at Berkeley devoted to the art of eighteenth-century Venice can be traced to the enthusiasm of museum trustee and collector Werner Z. Hirsch for such a project. His long-standing interest in the art of Giambattista and Domenico Tiepolo, as well as the presence at Berkeley of such noted Tiepolo scholars as Svetlana Alpers and Michael Baxandall, suggested the appropriateness of developing such a project. I can only hope that they are pleased with the result, however far it may stray from the more typical monographic product.

Professor George Knox has made a vital contribution to *The Mask of Venice*. In addition to his essay for this volume, his thoughts at various stages on my theme and checklist, as well as his generosity in sharing the fruits of his many years of thinking about Giambattista and Domenico in particular, went well beyond my expectations and were always most welcome. I am also grateful to all the scholars who have worked on Tiepolo and the art of eighteenth-century Venice in the past, such as William Barcham, Francis Haskell, and Michael Levey, as well as Paul Scolari, who made available to me his unpublished survey of Tiepolo drawings in California collections.

A number of individuals in Berkeley have made essential contributions to the development of *The Mask of Venice*. First among them is Deborah Zafman-Keitt, graduate student in the Department of the History of Art, who has served as my research

assistant. Her intelligence, diligence, extraordinary good nature, and personal warmth are an all too uncommon combination within the field and have collectively helped keep me on track. Further, she marshaled the (then) undergraduate troops who have, with Deborah, contributed all but four of the catalogue entries that follow. They are Jane Hyun, Lee Anne Loomis, Charity Urbanski, and Yao-Fen You; their initials appear after the respective entries, and my thanks are due to each.

Various staff members of the Berkeley Art Museum have made their usual energetic commitment to bringing a complex project together while juggling many other responsibilities at the same time: first and foremost, Curatorial Assistant Eve Vanderstoel for her work on every aspect of the exhibition and catalogue, and for an eye for detail without which this project might never have come together; Education Curator Sherry Goodman for working with me to devise a strong series of interpretive programs; Exhibition Coordinator Lisa Calden for handling the complex issues of loan processing and shipping; Designer Nina Zurier for, as always, designing a welcoming home for the exhibition in our challenging gallery spaces; Development Director Janine Sheldon and Grants Writer Thea Vicari for their work in securing the needed funds to get this project off the ground.

At the lending institutions I particularly thank Suzanne Boorsch in the Department of Prints and Drawings at the Metropolitan Museum of Art for bringing a number of prints to my attention while working on her own Venetian project. Robert Flynn Johnson of the Achenbach Foundation for Graphic Arts, Fine Arts Museums of San Francisco, and Betsy G. Fryberger of the Stanford University Museum of Art also gave generously of their time and made available key loans to a regional sister institution. For their help in cataloguing works for this exhibition and for their devotion to making a place for old-master prints in California, I—and all lovers of prints—owe a great debt to R. E. Lewis and to Jan Lewis Slavid.

For the production of this volume I am especially grateful to Christine Taylor at Wilsted & Taylor for shepherding this project along and working with our tight timetable, and I thank Pat Soden at the University of Washington Press for enthusiastically undertaking its distribution.

J.C.S.

Lenders to the Exhibition

Ackland Art Museum, The University of North Carolina at Chapel Hill

Antonio's Antiques, San Francisco

The Art Museum, Princeton University

The Baltimore Museum of Art

Mr. and Mrs. Richard S. Braddock

The Detroit Institute of Arts

Professor and Mrs. Lorenz Eitner

Fine Arts Museums of San Francisco

Grunwald Center for the Graphic Arts, UCLA

Dr. and Mrs. Werner Z. Hirsch

Honig Family Collection

Bernard Jensen

The Metropolitan Museum of Art

Museum of Fine Arts, Boston

National Gallery of Art, Washington

New Orleans Museum of Art

The New York Public Library

The Pennsylvania State University Libraries

Philadelphia Museum of Art

San Francisco Museum of Modern Art

Santa Barbara Museum of Art

Peter Jay Sharp Collection, courtesy National Academy of Design

Stanford University Art Museum

University Art Museum, University of California, Santa Barbara

University of California, Berkeley Art Museum

Harry and Frances Whittelsey

Private collections

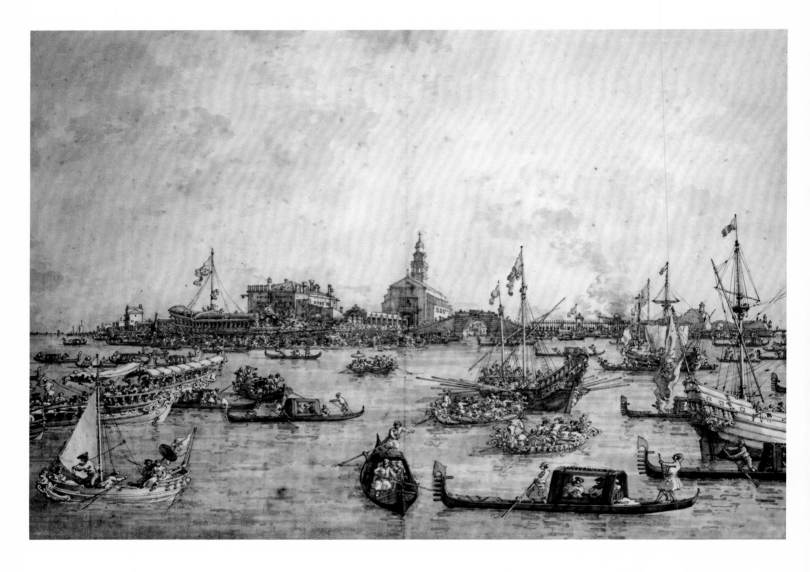

FIG. 1. *Antonio Canaletto,* Festivals of the Doge: The Bucintero
leaving S. Nicolo di Lido. *Pen and brown ink with gray wash,
heightened with white, over graphite on laid paper, 38.6 × 55.7 cm.
National Gallery of Art, Washington, Samuel H. Kress Collection,
© 1996 Board of Trustees*

Masks and Meanings in Tiepolo's Venice

James Christen Steward

WHEN THE FRENCH POLITICAL PHILOSOPHER Montesquieu visited Venice in the first half of the eighteenth century, he observed, "My eyes are very pleased by Venice; my heart and mind are not." This neatly sums up the dilemma posed by the city, at least to sensitive observers, in the last years before the final demise of the Most Serene Republic in 1797: the city was undergoing an economic and political decline while at the same time experiencing a widespread renaissance in the visual arts, a renaissance led, qualitatively, by Giambattista Tiepolo. This dichotomy, along with the implications of looking, of surfaces and depths, is at the core of the present exhibition, and each half of the apparent contradition will need to be examined in turn.

That Venice in the eighteenth century was practically in free fall within the European power structure has become a commonplace of historians, social and otherwise. This descent is measurable in many areas: Venice's dominions shrank radically, with the definitive loss of holdings in Greece, Turkey, and the East in 1718; foreign trade had been in steep decline for over one hundred years since new trade routes to the East had opened; the ruling class of noble families was equally diminished. Indeed, the nobility had been shrinking from about 1550. Since nonnobles were totally excluded from government, the Venetian Senate, in whom power ultimately resided, was led to elevate large numbers of new men (not families) who reinforced conceptions of the nobility as a caste of wealth and administrative expertise. Of these new members, three-fifths were merchants or traders, one-fifth were lawyers and professional men,

and one-fifth were nobles of the terra firma, the mainland surrounding the city itself. These newcomers were often despised: when Ludovico Manin, whose wealthy family had been ennobled only in 1648 (late by Venetian standards), became doge in 1789, a contemporary remarked that it was the end of the Republic.[1] In the end this may have been prophetic, for Manin proved to be the last doge, although blame for the city's ruin cannot be laid at his feet.

Strict class distinctions operated throughout Venetian society, including within the nobility, where history and wealth accounted for much. Society was officially divided into three castes: the *nobilii*, or nobility, which was in turn subdivided into three groups and which in 1770 included only 3,557 of Venice's inhabitants; the *cittadini*, or citizens, numbering 5,211 in the same year; and the *popolari*, or people, which included the lion's share of the city, some 125,239 potentially teeming bodies. Equally fundamental is the fact that, as the social historian Oliver Logan has pointed out, Venice in the eighteenth century was constricted by "economic, political, and social structures that had become ossified."[2] Its leading politicians were largely conservative, and many were hostile to any form of political or social experimentation, favoring instead a hoped-for revival of Venice's mercantile tradition while at the same time pointing out the evils of luxury, disproportionate wealth, and poverty that plagued the city. These leaders recoiled in the face of a changing Europe: Venetian censors banned the writings of Rousseau and Helvetius, although they could not stop these texts from becoming widely known. Even comedies written for the Venetian stage were subject to censorship, too, from 1749, and it is likely that painting would have met the same fate, had artists not largely refrained from social criticism in their work.[3]

Important issues such as the precipitous decline in foreign trade or widespread poverty went largely unaddressed by the state. Poverty was indeed expanding exponentially: by the 1790s, two-thirds of the population of Venice lived in very poor conditions. The number of those defined as poor and living off the state grew from a mere 445 in 1586 to 17,956 in 1760, to 23,015 in 1787—when fully one-sixth of the city was living on officially administered charity.[4] Instead of attempting to address this overwhelming reality, the Republic became obsessed with petty rules governing conduct, especially that of the nobility. Dress, protocol, the publishing and import of books, studio conditions for artisans—these were the principal governmental concerns of the day, and they were strictly regulated. Sumptuary laws required, for instance, that women dress in black—except for foreigners, the wives of ambassadors, and relatives of the doge. Even the languishing book trade, which at one time made Venice the leading producer of books in Europe, was subject to such stringent control that books were burned publicly in the Piazza.

Political and economic decline in Venice placed the Republic in an increasingly fragile position and brought with it a paradoxical surge in the number and importance of festivals, most notably Carnevale. As Oliver Logan has noted, "Now that she was no longer the defender of Italian freedom, the bastion against the Turks and the great

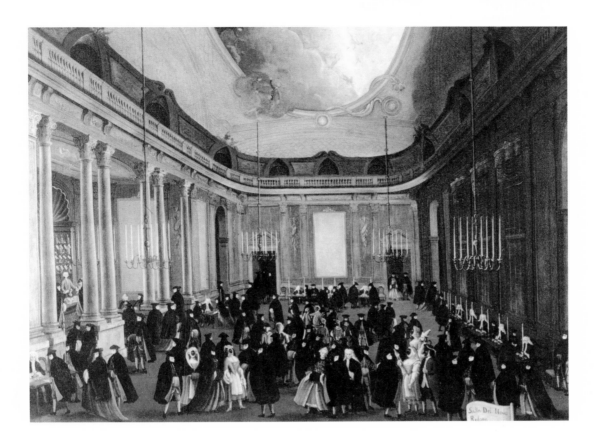

FIG. 2. *Gabriele Bella,* The New Foyer (The Ridotto).
Oil on canvas, 95 × 122.5 cm. Museo Correr, Venice

emporium of the Christian Mediterranean, the leaders of her society might divert themselves with extravagant but perhaps mechanical and unreflecting celebrations of the eminence of their own houses."[5] The sheer number of official festivals and processions, such as the coronation of the doge depicted by Giovanni Battista Brustolon (cat. no. 4), was extraordinary, numbering at least two per month,[6] in addition to the festivities of Carnevale, which lasted a minimum of three months. Venice in the eighteenth century was already a tourist center; Carnevale's status as a draw for tourists is attested by Peeter de Jode's elegant early-seventeenth-century engraving (cat. no. 3) of the subject. The city's elaborately staged festivals, ceremonies, and processions, such as the kind seen in numerous paintings and drawings by the great observer of Venice's public life, Canaletto—including drawings of the doge's festivals (fig. 1)—served to entertain and distract visitors. The pleasure activities of boating or gambling at the Ridotto, the state-controlled casino that Gabriele Bella painted in the 1780s with static charm (fig. 2), where the nobleman holding the bank appears unmasked in a masked crowd, served a similar function. Such public events were thus a kind of disguise, camouflaging the realities of decay and decline to which so many of Venice's inhabitants were

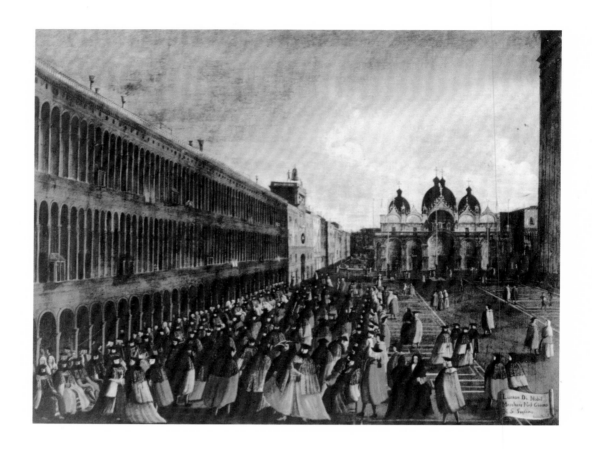

FIG. 3. *Gabriele Bella,* The Boxing Day Promenade with Masks.
Oil on canvas, 94.5 × 123 cm. Museo Correr, Venice

subjected. Disguise, then, begins to emerge as an issue central to Venetian life: even the great palazzos fronting the canals were marble-fronted but of brick behind, a kind of elaborate stage set disguising the reality of the city behind an elegant facade.

Carnevale took on its general form in the second half of the thirteenth century, uniting popular forms with political ends as a way of bringing the city together. The festival served a number of purposes, lending eighteenth-century Venice a false air of continued magnificence, bringing foreign (specifically tourist) money to the Republic, and distracting the masses from potential unrest. The population of Venice effectively doubled during the months of the festival, which began officially on 26 December (fig. 3), although at least from the early 1700s certain aspects of Carnevale, notably the wearing of masks, were evident from as early as 5 October. It must be said, however, that this six-month celebration was a reality only for the nobility: for the masses, Carnevale lasted only the few weeks immediately preceding the beginning of Lent. Even so, the power of Carnevale was such that when the Doge Paolo Renier died 13 February 1789, the announcement was delayed until 2 March so as not to interrupt the public festivities. And despite the general populace's involvement in the festival, Carnevale still

preserved class distinctions: a noble might participate in the running of the bulls, masked as a figure from the *commedia dell'arte* to hide his individual identity, but he would be accompanied by servants to inform spectators of his rank.[7]

The emblem of Carnevale was, literally, the mask, a term that could apply to the wearer as well as to the object, attesting to the depth of identification of individual with disguise. The masks of Carnevale derived most immediately from the masks worn on stage in the traditional *commedia dell'arte* (see, for example, cat. nos. 30 and 31) and more distantly from masks worn in traditional societies, and shared with the latter certain basic characteristics thought to be universal to the practice of masking: simultaneously an act of simulation or mimicry and of disguise, masking could be alienating and transporting, intoxicating and liberating.[8] At the same time, to be masked privileges the wearer, protecting subjectivity and privatizing individual identity: being masked displaces meaning from who one is to how one behaves. The carnivalesque festival was, through the use of masks, "an interregnum of vertigo, effervescence, and fluidity in which everything that symbolizes order in the universe is temporarily abolished so that it can later re-emerge,"[9] according to Roger Caillois, a philosopher of game playing. For Mikhail Bakhtin, such festivals were, like art itself, fundamentally about unmasking, disclosing the unvarnished truth hiding under a veil of false and arbitrary information.[10] The wearing of masks, then, could serve to reinvigorate, renew, and recharge both individuals and society.

The most notorious of mask types has been thought to be the black mask, associated with amorous intrigue and mysterious plots against prevailing powers. This type of mask, again quoting Caillois, liberates the wearer from social constraints: "In a world in which sexual relationships are subject to many taboos . . . the black mask . . . traditionally symbolizes the means and often the announced decision to violate these taboos."[11] The wearing of masks at Carnevale thus becomes a kind of release from, even a compensation for, the decency and prudence deemed necessary throughout the rest of the year. In the case of Venice, still in the eighteenth century a staunchly Catholic city in which most public art played a religious function, the effect of the mask in providing release from dominant moral codes must have been considerable.

Perhaps the most important form of mask in the Venetian Carnevale, as an object with which the wearer identified, was the *bautta*, the combination of mask, black cape, and tricorn hat that came to symbolize the festival. The *bautta*, whose name is commonly thought to derive from the cry "bau, bau" used to frighten children, was reserved for the most fortunate members of society—nobles and part of the middle class.[12] Part of its function was to allow wearers to pass through the turbulent city without being disturbed, without, in the words of Giovanni Comisso, "the indignity of contact with the masses."[13] At the same time, wearing the *bautta* in public places had the effect of checking displays of excessive luxury in apparel, something of increasing concern to Venice's great and good as the divide between rich and poor became more noticeable and as revolution began to sweep Europe.

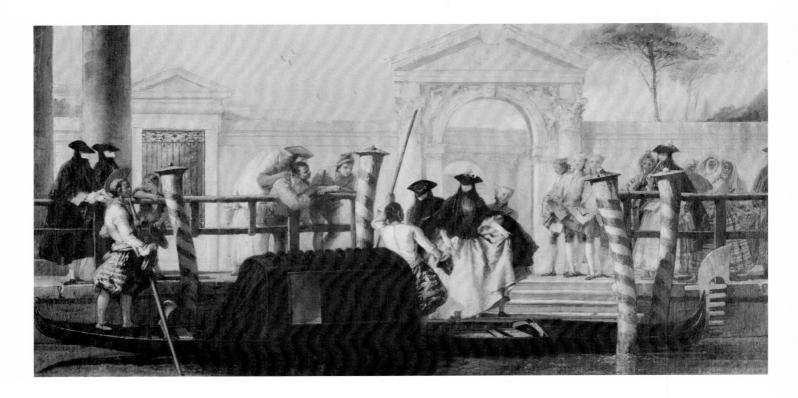

FIG. 4. *Giovanni Domenico Tiepolo,* Departure of the Gondola.
Oil on canvas, 35.6 × 72.5 cm. Private collection, New York

As part of the control of the trivial we have already observed, the wearing of the
bautta was strictly regulated. Women were required to wear it at the theater, and no-
bles and foreigners were obligated to don it for most official ceremonies. It brought to
the heart of the city a kind of otherness, as if the wearer were transported to another
land where he was unknown. Many paintings from the time, such as Domenico Tie-
polo's *Departure of the Gondola* (fig. 4), evoke this mysterious, cloaked quality. Eventu-
ally, the city's reputation for disguise garnered for it a not always savory reputation
for attracting people who came hoping to escape—to hide from their creditors, their
families, or foreign authorities.

Two other forms of Carnevale masks bear specific mention here, for they spoke to
the relationship between men and women in the male-dominated, Senate-controlled
world of the *Serenissima* in the eighteenth century. The first of these is the *gnaghe*, a
mask worn by men to impersonate women. In addition to the mask, the wearer was
required to adopt a shrill tone of voice, in an attempt to imitate, stereotypically, the
voices of women. More revealing, perhaps, is the *moretta*, a black oval mask worn exclu-
sively by patrician women. What is particularly telling about the *moretta*, seen in many
paintings of the period such as the *Bal masqué* (cat. no. 10) in the style of Pietro Longhi
and what is often overlooked by most twentieth-century observers of masking, is that

it had no bands or strings but was instead held in place by the means of a button that the wearer clenched between her teeth. Speech was effectively precluded, lending what was thought to be an additional air of mystery to the encounter between a nobleman, most likely wearing the *bautta*, with the masked woman incapable of speech. According to Adriano Mariuz, the *moretta* fell out of fashion about 1760, for reasons that are not entirely clear.[14]

The derivation of Carnevale masks from traditional stage comedy and the issues of disguise and role-playing inherent to the theater suggest that we should turn for a moment to the part theater played in the life of the Serene Republic. This role remained a vital one throughout the Republic's last one hundred years. In the eighteenth century there were some eighteen theaters in Venice, many of which were quite large: the Teatro di San Salvador could hold as many as two thousand spectators. In addition to these, there were private theaters in many of the villas of the terra firma, as well as touring companies, both large and small, everywhere. Despite this abundance of venues, the Venetian stage tradition was not without its own turmoil. The dominant theatrical form of the day, the *commedia dell'arte*, came under attack midcentury for being monotonous in its set themes, for having actors unequal to the task of improvisation that the form required, and for providing too many occasions for obscenity. This last must surely have been the aspect that brought the *commedia* to the attention of a censorial state, although the latter's concern may have arisen from a desire not to protect the populace from unhealthy ideas but to avoid offending tourists, who had by then become the city's bread and butter.

Reform came in 1748, almost simultaneously with censorship, in the person of Carlo Goldoni, the Venetian playwright who, like Molière, attempted to replace the strange, often formless and repetitive nature of the *commedia* with more varied plots and fully developed character parts. These latter, known as *personnagi virtuosi*, "noble characters," are in Goldoni's work, as in Molière's, reminiscent of the theater of the Enlightenment and describe the rationalizing tastes of the eighteenth century, which touched even Venice. Goldoni stressed nature, simplicity, and propriety, characteristics distinctly at odds with the *commedia* and with Carnevale. This may suggest why traditional theater made a tremendous and rather quick comeback—so much so that Goldoni left Venice definitively in the early 1760s. In any case, despite the taste for naturalism that Goldoni's writings may have created, traditional masked *commedia dell'arte* could still sell out substantial Venetian theaters as late as 1786.[15] And it came to life in the streets and on the canals of Venice every year during the months of Carnevale.

One important distinction should be drawn between masking's effect on the stage and its effects in daily life. In the latter, masking could be liberating, providing the possibility of officially sanctioned uninhibited behavior through the guise of anonymity. Onstage, however, in the traditional *commedia dell'arte*, the mask defined an actor's behavior fairly strictly, even though the freedom of improvisation was central to the form. The mask assigned to its wearer on the stage a mode of behavior and thus could

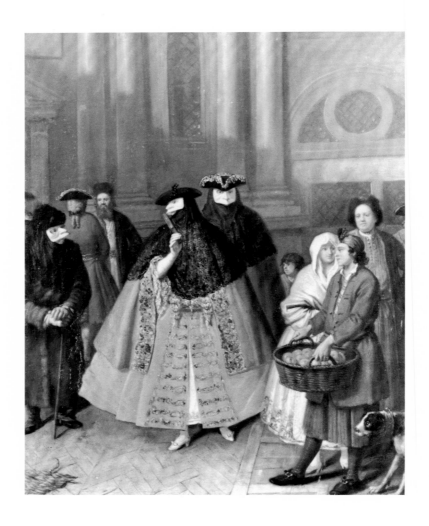

FIG. 5. *Pietro Longhi,* Masked Figures with a Fruit Seller.
Oil on canvas, 62 × 51 cm. Ca' Rezzonico, Venice

be thought of as limiting. Both the liberating and the confining aspects of masking will need to be addressed when we turn to the visual arts.

Carnevale's act of masking, theater, and production and representation in the visual arts have obvious links beyond simple matters of depiction. All are capable of providing a space for free expression and are representations, creators of illusions, that are based on invention, play, make-believe, or, at the least, interpretation. Yet the visual arts of eighteenth-century Venice also stand apart from actual social practice in important ways. The issues of control and decline could rarely, if ever, be confronted directly in painting: there was no market for such work, and in any case the Senate oversaw artistic production. When public satire appeared in limited guises, it was not well received by the government or the public at large and could lead to literal banishment from the city.[16] As Michael Levey has put it, "The failure of eighteenth-century Venice

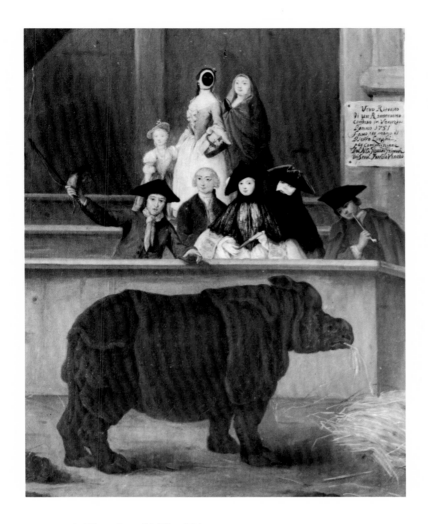

FIG. 6. *Pietro Longhi,* The Rhinoceros.
Oil on canvas, 62 × 50 cm. Ca' Rezzonico, Venice

to produce any open painted comment upon the state of the city and society was not quite an accident; the artists, unconsciously perhaps, conspired with the government to agree to ignore certain things and to emphasize others. The band played louder to drown the pistol shots."[17] Even so, a number of Venetian artists found ways of commenting on contemporary life. One of the greatest of these was Pietro Longhi, much admired by Goldoni as a fellow searcher after "Truth."[18] Longhi was celebrated in Venice's advanced circles, and his works may have been seen as somewhat subversive: as Francis Haskell has pointed out, the most enthusiastic praise of Longhi's work came from "men who were anxious to look more steadily at the actual circumstances of Venetian life than was usual at the time."[19] Many Venetian critics championed Longhi for works such as the *Masked Figures with a Fruit Seller* (fig. 5), not so much as an example of the finest Venetian painting—for Longhi could be markedly uneven with his

brush—but out of their distaste for excessive frivolity. Frivolity might be found in un-expected quarters: caricature, specifically the caricatures of Domenico Tiepolo, was seen as the emblem of frivolity, and critical remarks were made to this effect as early as 1749.

Longhi's *Rhinoceros* of 1751 (fig. 6) is often heralded as his masterpiece. Recording the arrival of exotic animals at Carnevale, specifically the first rhinoceros in Europe for centuries (the last had been recorded by Dürer) that had arrived ten years before Longhi painted it, the depiction is elevated in part by its psychological complexity. The composition reminds us of theatrical settings, but now we look at the audience (where we can identify figures wearing the *bautta* and the *moretta*) as much as at the per-former. There is something sad, even futile, in the expressions of the unmasked onlook-ers, for whom the only entertainment is seeing the animal in the first instance. Does the painting then become a metaphor for jaded Venetian tastes, overstimulated by years of pomp and circumstance?

Certainly Longhi was influential. Giovanni Battista Piranesi's *Masked Figures at a Punch and Judy Show* (fig. 7), a drawing of about 1743–47 by the famed engraver, is most likely based on looking at Longhi but is one of only five related drawings of every-day Venetian life executed by Piranesi before he settled definitively in Rome. The drawing captures a typical public entertainment during Carnevale; the central masked figure, leaning his weight on his left leg, resembles masked figures in Longhi's work, although Piranesi's execution is more fluid and self-confident. Piranesi's drawing, in turn, may have influenced Giambattista Tiepolo in drawings such as *The Masquerade* of about 1760, in which the masked figure seen from the rear is accompanied by a Punchinello.

Like Pietro Longhi and his son Alessandro, Francesco Guardi (who was appren-ticed in Giambattista Tiepolo's studio about 1734, although he became best known for his city views and canal scenes) was able to characterize individuals through gesture and posture—an important talent when it came to representing masked players. In *The Ridotto* (fig. 8), one of his most movemented works with figures, he represents the city's state-run gambling den as a place of amorous intrigue. Theatrical entertainment existed in Venice outside the city's theaters, and the Ridotto—ultimately closed in 1774, a victim of concerns over luxury and laziness, to be replaced by a number of clandestine gaming houses—was one of the most inherently theatrical settings for in-trigue. Guardi's painting may have been intended to illustrate a play by Goldoni, or perhaps to contrast the wisdom of Venice's aristocrats, who placed their unmarried daughters safely out of harm's way in convents, to the indifference of middle-class mer-chants who allowed their daughters, as here, to lead a debauched urban life.[20] In any event, it is one of Guardi's most animated scenes and fully captures the stagelike qual-ity of masked Venetians at play.

Genre scenes of everyday life found perhaps a more important and welcoming home in printed media. Gaetano Zompini's volume of engravings entitled *Le arti che*

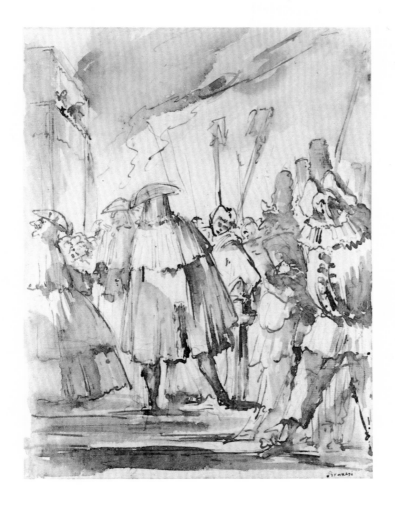

FIG. 7. *Giovanni Battista Piranesi,* Masked Figures at a Punch
and Judy Show. *Pen, ink, and wash, 25.8 × 18.3 cm.*
Hamburger Kunsthalle

vanno per la via nella città di Venezia (see cat. nos. 11 and 12) can be seen as a collection
of street cries, like so many volumes produced in London during these years. Zompini,
however, often combines the quotidian with Carnevale's release from the everyday.
The engraved scenes, such as *Lantern Bearer* included in this exhibition, depict the
lives of the poorest members of the working class in Venice. Zompini's proper subject,
then, is not the elegantly masked or cloaked figures but the weary lantern bearer who
lights their way. Some ninety-five preparatory sketches for the engravings survive in
the Museo Correr in Venice and suggest how Zompini arrived at a style devoid of for-
mal elegance and thus unusual in Venetian art. While moderating his style to the more
typically fluid lines of Venetian painting, Pietro Longhi may have based some of his
paintings on Zompini's compositions: Longhi's *Masked Figures with a Fruit Seller* has
a clear visual relationship with Zompini's *Lantern Bearer.*

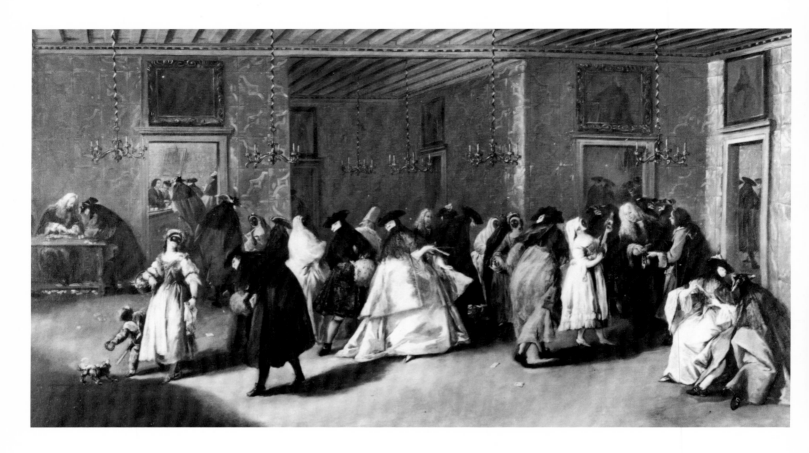

Michael Levey has characterized Domenico Tiepolo as the greatest Venetian practitioner of genre (in the sense of topical commentary on daily life) for avoiding the trap of the commonplace into which Pietro Longhi fell.[21] Certainly Domenico's genre images include a note of humor entirely absent in Longhi's work, or Guardi's for that matter; Domenico's view of life seems to be that it was at once absurd and delightful. Perhaps the important point here is that it was a view that remained fundamentally private, revealing itself only in his drawings, most likely distributed among his friends, in his frescoes for his own villa, and in frescoes for the Villa Valmarana in the terra firma, such as *The Charlatan* (fig. 9).[22] Domenico's drawings were clearly among the most advanced of their time, even with reference to Goya's work (which both Giambattista and Domenico might have seen in Spain). Both Domenico's *Scenes of Contemporary Life*, begun in about 1791, and his Punchinello drawings, the *Divertimento per li regazzi* of 1797–1804 (begun in the same year in which the *Serenissima* surrendered to the French), observe daily life in Venice; the latter series may have been intended as a subtle comment on the ancien régime. The *Scenes* certainly poke fun at the nouveaux riches of Venice, the social climbers, with their overblown heads and coarse features

(see, for example, cat. nos. 39 and 40). But in the second series, the *Divertimento*, Domenico seems to identify with his figures rather than to use them to critique his Venetian compatriots. Domenico's Punchinello (see cat. nos. 36 and 37) functions not so much as a figure of obscenity or dishonesty to lampoon his contemporaries but as Everyman.[23]

A fondness for working in series and for referring to his father's production marks Domenico's oeuvre: both series seem to derive from a study of Giambattista's work, the *Scenes* from Giambattista's caricatures and the Punchinello drawings from the father's loose studies of the same figure. Further, as George Knox has convincingly suggested, the origins for Domenico's Punchinello—slim and agile by comparison with the often squat figures found in earlier representations—seem to lie in Giambattista's interest in the *ragazzi Sanzenati*, the boys of the quarter of San Zeno in Verona, during the festival of *venerdi gnoccolare*, a festival held the last Friday in Carnevale and devoted to cooking, especially the cooking of gnocchi.[24] Thus, even in works intended to divert or amuse, Domenico is borrowing from a source that has its origins in the observation of real life. The trajectory of these works, from Giambattista's more direct observation (a surprising discovery, it must be said) and the humorous observations of Domenico's gentle prodding in the *Scenes of Contemporary Life* to the stylization of the *Divertimento*, follows something of the same movement traversed by the public's taste in theater: the *Scenes of Contemporary Life* then become the equivalent of Goldoni's theater, while the *Divertimento* are the equivalent of the baser, more broadly described *commedia*.

This leads us, in a circular way, back to the work of Giambattista Tiepolo, which is at the core of this exhibition. Most critics describing the work of Giambattista—remembering that until 1955 there was, remarkably, no book about him in English—have argued that it provides the strongest contrast with a taste for the everyday as described by Pietro Longhi or Francesco Guardi. Oliver Logan, for example, characterizes Giambattista as being "always prepared to transport his patrons into the empyrean or invite his viewers into a fairyland where splendidly dressed Venetian ladies of the sixteenth century consorted with antique heroes. Here it was still the golden age of Venice." He was not the minister to a living mythology but rather to "nostalgia and escapism."[25] By contrast, Logan describes Longhi as revealing "with a merciless eye" the foibles of his age.[26] Or, more recently, Adriano Mariuz has written that "when Tiepolo focused on contemporary humanity he saw only caricatures: each individual is isolated inside a ridiculous body."[27]

Yet Knox's discovery of the origins of Domenico's Punchinello type has already begun to suggest that the roots of Giambattista's work lie closer to the everyday in Venetian life than has previously been assumed. Certainly Giambattista is looking at the past; his taste for theatrical antique costume seems to have come very much through the lens of Veronese, an artist championed in the eighteenth century. And Giambattista clearly fits into eighteenth-century Venice's discovery of the distinctiveness of Venetian painting, from Titian to Tintoretto to Veronese, and by extension to

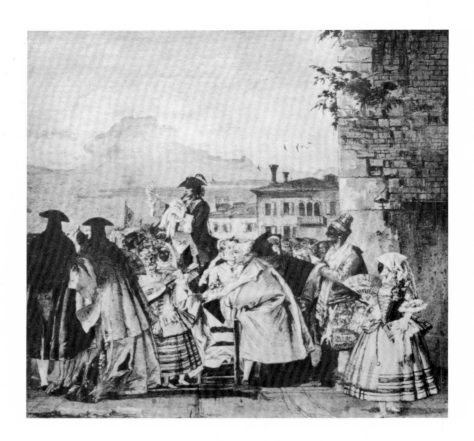

FIG. 9. *Giovanni Domenico Tiepolo,* Il Ciarlatano *(The Charlatan). Fresco. Villa Valmarana, Vicenza*

Giambattista himself. But this was no mere nostalgia. Tiepolo's insistence on the importance of the past, on the world of the antique mixing with that of the Renaissance, is clearly embedded in the spirit of the Englightenment, in which the antique past inspired noble behavior and virtue in the present. Antiquarian studies remained the outstanding intellectual passion of the Venetian intelligentsia in Tiepolo's time. Even if Venice remained largely removed from the world and the writings of Rousseau and Voltaire, in this respect Venice was of the moment.

Such issues suggest again why Giambattista's paintings have no place in the present project. The artist himself declared that in painting the painter should "aspire to the Sublime, to the Heroic, to Perfection,"[28] leaving little room for the everyday or the more purely imaginative. For these one must turn to his works on paper. What Andrew Robison has described as the "mysteriously capricious subjects involving exotic oriental figures in settings with echoes of antiquity"[29] are known to us only from Tiepolo's drawings and etchings. His taste for caricature emerges exclusively from his drawings. To turn to Tiepolo's prints and drawings for clues as to his artistic identity is scarcely a twentieth-century anachronism or misuse of the past: his drawings were

avidly sought out by engravers and copyists and even by foreign collectors as early as 1732, when Vincenzo da Canal referred to their popularity.[30]

Perhaps the most obvious characteristic to emerge from looking at Giambattista's two print series, the *Vari Capricci* and the *Scherzi di fantasia*, is the extent to which similar motifs and figures reappear from one print to the next and from one series to the next, despite the fact that neither series seems to involve any explicit or implicit narrative. Standing wise men in oriental costume, emaciated dogs, young soldiers, urns emblazoned with masklike motifs, these are the dominant refrains of the etchings. Such motifs can be found, in their genesis, in the artist's drawings, where the works known as the *Sole figure vestite* (cat. nos. 15–18), the single dressed or standing figures, explore the same facial types, part oriental, part gypsy, that appear over and over again in the prints. The sage, especially, presents a seemingly impassive or ambiguous front that, when combined with other figures, sets him apart as a sort of masked stoic. Even when alone, these figures possess a certain masked quality, like the stock stage characters of the *commedia*.

Previous scholarship has readily found links between the sheets of single figures and the prints. But beyond the clear lineage between the drawn and etched sage, it has also been more tantalizingly suggested that the *Capricci* may have a direct connection with Venetian caricature and in turn with the *commedia*. Francis Haskell has proposed that Antonio Zanetti the Elder's caricatures, including those of the leading operatic figures of the day, which Tiepolo almost certainly would have known, may have helped shape his work as a printmaker. Zanetti's *Self-Portrait in a Mask, Drawing a Caricature* (fig. 10) underscores this possibility and speaks again to the role of masking: caricature is a type of disguise for the artist, symbolically donning a mask as Zanetti literally does here. Marco Ricci's rather caricatural drawing of the castrato Farinelli makes the same point, but does so through the spectacle of the stage (fig. 11). If Haskell is right—and the suggestion is a compelling one—such a lineage suggests a different meaning for Giambattista's caricatures, linking them as midway points between observation of the everyday and the more personal workings of the artist's imagination.

It should be noted that even the title *Scherzi di fantasia* may not be as straightforward as it at first appears. It may in itself help to decode the meaning of the series, for the word *fantasia* had a different value in the eighteenth century than it did before or than it does for the present-day reader. In the sixteenth and seventeenth centuries the word signified an almost superhuman force of imagination and *invenzione*. Only in the eighteenth century did it take on a more delicate overtone to include the fanciful, but it still contained hints of the grandiose and the heroic that today's definition would overlook.[31] Giambattista's work indeed seems to combine the fanciful and the heroic in ways that have often troubled critics unable to decode the meaning inherent in such a combination.

While Giambattista's subjects recur frequently, the interpretation differs each time he uses them, as it does in eighteenth-century musical variations on a theme. The

FIG. 10. *Antonio Maria Zanetti the Elder,* Self-Portrait in a Mask,
Drawing a Caricature. *Pen and ink, 28.4×20.9 cm.*
The Royal Collection © Her Majesty Queen Elizabeth II

recurrence of these stock figures, Tiepolo's actors or *dramatis personae*, provides a good deal of the pleasure to be had in looking at the prints, as we watch for members of the troupe to return in varied roles and situations, as we might seek out favorite performers in modern repertory theater. It is plausible, I think, to suggest that the stock characters of Giambattista's prints and drawings finally seem to derive both from the artist's observation of contemporary life—however much they are filtered through his thick artistic lens—and from the contemporary theater, most notably the *commedia*.

The meaning of the two print series continues to perplex scholars and critics. Adriano Mariuz, writing in the catalogue accompanying *The Glory of Venice* exhibition in 1994, remarks that "Tiepolo's etchings are like the distilled essence of his work, the mercurial element in his art. He used the copperplate like a magic mirror to reflect some of his innermost thoughts." Mariuz then stresses the almost complete elusiveness

FIG. 11. *Sebastiano Ricci,* Farinelli in an Oriental Role.
*Pen and ink over lead, 30 × 16.7 cm. The Royal
Collection © Her Majesty Queen Elizabeth II*

of the subject matter, which he ultimately finds to be "insoluble."[32] This is perhaps unintentionally revealing for suggesting that the subject matter may be, in fact, the revelation of the artist's innermost thoughts. In this sense subject matter, as it is traditionally thought to apply to art made before the twentieth century, does become "irrelevant" and yet central at the same time, in the same way in which subject matter may be described in the work of Wassily Kandinsky.

In combining his stock actors as he does in the *Scherzi* and *Capricci* series, Giambattista evokes what have been described as "the contrasting yet complementary themes of life and death, youth and age, primitive instinct and ancient wisdom."[33] In so doing, the artist, then in middle age and the most powerful and sought-after artist in Venice, seems to be searching for answers to the meaning of life, without taking recourse to the standard practices available to him in allegory. He does so by posing questions,

questions phrased in what may be a fundamentally private language but one that derives from the life of the city in which he developed. Only the uncommissioned media of drawing and printmaking afforded Tiepolo the opportunity to reveal, to unmask himself, and to address such basic issues as the meaning of life, in a vocabulary that need please only him. It is, I think, a mistake to feel that we are not always equipped to read the "answers," for question and process seem to be at the heart of these profoundly personal, and profoundly Venetian, works.

With the exception of his caricatures, which derive loosely from the observation of contemporary life, Giambattista did not carry out genre scenes and did not seem to be interested in attempts to reveal the "Truth" about his declining city. The role of the noncommissioned work thus becomes especially important; the workings of Giambattista's imagination function as the counterpoint to the stage setting of his commissioned works and most closely integrate his identity and artistic musings into the context of his time. The kind of art he created, after all, reflects a particular attitude about theater, about invention and creation, and about illusion, fantasy, and play. Giambattista's prints finally may reveal his greatest artistic truths. Yet their mystery remains, like the unknowability of what is masked, altering and revealing even as it hides. Some of the later misreading of Giambattista's works on paper almost certainly derives from the fact that it was the imaginative in it that came to be sneered at in the artist's own lifetime, an age of increasing intellectual scrutiny in which the French critic and *encyclopédiste* Denis Diderot preferred Teniers to Watteau. Michael Levey has penetrated as close as any critic to the central meaning of Giambattista's printed work in writing that "these works are private fantasies of the artist's, revealing almost an obsession with certain motifs which possess for him personal meaning and magic: in some ways equivalent to the inspired doodles which Leonardo da Vinci repeated again and again in his note-books."[34] But, contrary to Levey's reading, these are works in which subject matter remains vitally linked to both the external world of Venice and the internal world of Tiepolo's mind, so cleverly and perhaps necessarily concealed in his painted works. The movement described by *The Mask of Venice* is finally a movement from the outside in, from the staged world of official Venice to the stage of Tiepolo's mind, from the social world to the world of imagination, to reveal, through the liberation of the mask, the Tiepolo behind the mask.

When the Serene Republic fell to the French in 1797, its demise may well have been seen by many of its inhabitants as emblematic of the end of the ancien régime. Public rejoicing initially greeted the victory of the French: images of the lion of St. Mark were pulled down throughout the city and smashed. From 1797 the image of Venice as a city of mourning, so well suited ultimately to Thomas Mann's *Death in Venice*, gradually replaced its festival reputation. And yet, even though much of Venetian Carnevale practice died out over the length of the nineteenth century only to be restored in the twentieth, the mask remains the greatest sign for a paradoxical situation in which what is Venetian becomes other, in which celebration becomes mourning, and in which "Truth" is both hidden and revealed.

NOTES

1. On this point, see J. C. Davis, *The Decline of the Venetian Nobility as a Ruling Class* (Baltimore: The Johns Hopkins University Press, 1962).

2. Oliver Logan, *Culture and Society in Venice, 1470–1790: The Renaissance and Its Heritage* (London: B. T. Batsford Ltd, 1972), p. 271.

3. A form of self-censorship in the arts certainly prevailed, for when a Venetian academy was finally formed in 1750 after years of debate, it was under the control of the Senate.

4. Jonard 1965, p. 87.

5. Logan, *Culture and Society in Venice*, pp. 270–71.

6. Jonard 1965, pp. 203–4.

7. Gilles Bertrand, "Venise au temps du carnaval," *L'Histoire*, no. 185 (February 1995): 64–69.

8. See Roger Caillois, *Man, Play, and Games*, trans. Meyer Barash (New York: The Free Press, 1961), p. 75.

9. Caillois, *Man, Play, and Games*, p. 87.

10. See Mikhail Bakhtin, *Rabelais and His World*, trans. Helene Iswolsky (1968; Bloomington: Indiana University Press, 1984).

11. Caillois, *Man, Play, and Games*, p. 131.

12. Bertrand, "Venise au temps du carnaval," pp. 65–67.

13. Giovanni Comisso, *Les Agents secret de Venise au XVIIIe siècle*, trans. Lucien Leluc (Paris: B. Grasset, 1944), p. 37 note 1.

14. In London and Washington 1994, p. 456.

15. Jonard 1965, p. 144.

16. See Levey 1994, p. 148.

17. Levey 1994, p. 150.

18. Haskell has suggested that Pietro Longhi may have inspired Goldoni's theater. See Haskell 1980, p. 323.

19. Haskell 1980, p. 323.

20. I am indebted for this reading to Mitchell Merling's catalogue entry in London and Washington 1994, p. 455.

21. See Levey 1994, p. 162.

22. One should be wary in reading the meaning of this fresco, for the *ciarlatani* could, besides being quack doctors, be actors in the *commedia* tradition.

23. See Knox 1983, p. 125.

24. See Knox 1983, p. 142.

25. Logan, *Culture and Society in Venice*, pp. 292–93.

26. Logan, *Culture and Society in Venice*, p. 292.

27. London and Washington 1994, p. 207.

28. Quoted in the *Nuova Veneta gazzetta* for 20 March 1762, not paginated.

29. In London and Washington 1994, p. 18.

30. See Adriano Mariuz, "Giambattista Tiepolo," in London and Washington 1994, p. 182.

31. Logan, *Culture and Society in Venice*, p. 289.

32. In London and Washington 1994, pp. 197, 198.

33. Adriano Mariuz in London and Washington 1994, p. 198.

34. Levey 1994, p. 216.

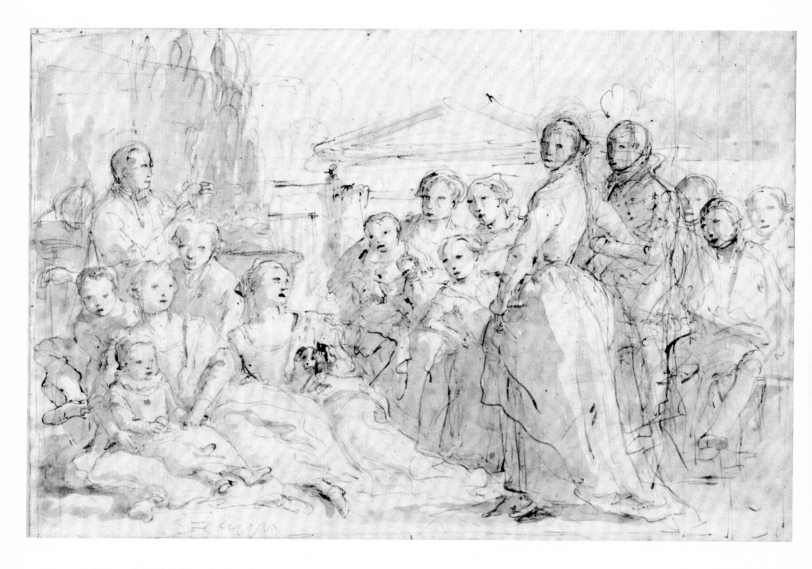

FIG. 12. *Giovanni Battista Tiepolo*, Family Group. *Pen and brown wash over black chalk, 24.1 × 34.3 cm. Private collection*

The Private Art of the Tiepolos

George Knox

*I*N THIS YEAR WE CELEBRATE the three-hundredth anniversary of the birth of Giambattista Tiepolo (1696–1770). His career and that of his son Domenico (1727–1804) span the eighteenth century in Venice. Although most of Giambattista's work was done in Venice and the Veneto, his field of activity stretched from Madrid to St. Petersburg, and his most outstanding work, the frescoes of the Residenz at Würzburg, can claim to be the most triumphant display of the art of painting north of the Alps.

The title of this exhibition rather conceals the fact that it is mostly about Giambattista and his son. In scope it does not concern itself with the grand public persona of Giambattista and the more modest public achievements of his son but rather with the private aspects of their activities. It focuses on those aspects of their work that appear to have been done for their own satisfaction, as a form of relaxation from the demands of patrons and the preoccupations of a successful public career. Sadly, we know relatively little about the private life of the Tiepolo family,[1] and the only contemporary account of his career is that of Vincenzo da Canal, written in 1732, when Giambattista was thirty-six years old. Thus we know virtually nothing of his views on art and other artists, and for his personal interests and preoccupations we have to rely on the evidence of the drawings and other material which do not bear directly on his public activities.

Both Giambattista and Domenico were passionate and prolific draftsmen. Their

drawings go far beyond the requirements of their professional commitments; far beyond any possibility of monetary gain; far beyond any practical consideration. In sheer numbers it would seem that each of them made about six times as many drawings as, say, Sebastiano Ricci or Francesco Guardi, and three times as many as Piazzetta. In fact, together they seem to have made about as many drawings as the rest of their Venetian contemporaries put together.

This impression may be due in part to the care they took to ensure the survival of their drawings. When in 1762 Giambattista, at the age of sixty-six, was faced with the unavoidable necessity of a journey to Spain, a journey from which he may have sensed that he was not to return, he caused the pen-and-wash drawings in his studio to be sorted into categories and mounted in handsomely bound volumes, which he placed in the library of Santa Maria della Salute. Six such groupings remain more or less intact to this day.[2] Two are dispersed but are fully recorded.[3] As regards the other main category, the chalk drawings, which are mainly studies for paintings, they too at that time or later were sorted into categories and pasted into existing sketchbooks, and of these two remain intact.[4] A mass of 847 drawings, 619 chalk and 228 pen, passed at the end of Domenico's life to Giovanni Domenico Bossi (1765–1853) and remained together until a sale in Stuttgart in 1882.[5]

Domenico's efforts to ensure the survival of his drawings are less well documented, but his chalk drawings appear to have been preserved indiscriminately together with those of Giambattista. His smaller pen drawings, though they survive in very large numbers, do not have any clear early history, save one grouping, the Beauchamp Album, which may have been sold out of the studio well before Domenico's death. This remained intact until 1965 and is completely documented.[6] His three large sets of folio drawings, on the other hand, certainly remained with him until the end of his life, and by great good fortune they seem to have survived intact, at least to a very large extent. The *Large Biblical Series*, some 250 to 270 drawings, seems to have been divided into two equal groups, perhaps in the 1830s: one of these, the Recueil Fayet in the Louvre, is apparently intact; the other half, which may be called the "Recueil Luzarches," was dispersed in the course of the later nineteenth century, but 72 items remained together until the Cormier sale in 1921.[7] We do not have any precise information about the second set, the *Scenes of Contemporary Life*, which may have amounted to about 100 sheets: these have been dispersed over the past one hundred years, but 22 appeared in the Beurdeley sale in 1920,[8] and today about 80 specimens can now be counted. The third set, with the recorded title *Divertimento per li regazzi* (the Punchinello series), amounting to 104 sheets and a title page, remained virtually intact until 1920,[9] when it was fully recorded in a set of photographs by Richard Owen.

Giambattista's characteristic manner of drawing in pen and wash does not appear to have become established until he was in his late thirties, at the time of his frescoed decorations of the Villa Loschi of 1734. This project required two allegorical figures in niches, and Giambattista turned for data to that standard handbook, the *Iconologia*

of Cesare Ripa. But here is a curious thing. Instead of just selecting the required figures and making the necessary studies, Giambattista went wild and made sixteen studies of various allegorical entities.[10] One might argue that these might all have been made for presentation to his somewhat pedantic patron, Count Nicolo Loschi, but it seems more likely that he was simply carried away by enthusiasm for a new genre and its possibilities. The drawings are very handsome and were immediately copied by the two young men who appear to have been in the studio at that moment, Francesco Guardi and Giovanni Raggi, both of them aged twenty-two in 1734.[11] During the later 1730s he got carried away again, making a long series of folio-sized drawings on religious themes, which form the greater part of the Orloff Album. These do not appear to have any direct bearing on any project for painting and are apparently work carried out entirely for its own sake.

Giambattista, now in his early forties, had had ample opportunities to study all the aspects of Venetian painting that interested him, and like all artists of the time, he was familiar with the print shops of Venice and their contents. In fact, from his early years he had been involved in preparing drawings for printmaking and book illustration.[12] But this was the golden age of print collecting, when Bartsch and Heineken were establishing the great collections in Vienna and Dresden and laying the foundations for the systematic study of prints. The great collection of prints and drawings in Venice at this time was that of Zaccharia Sagredo (1653–1729), and in 1739, after the death of his heir Gherardo, Tiepolo and Piazzetta were called on to evaluate the collection.[13] This would have certainly provided both with an opportunity, if they had not been able to do so earlier, to become broadly familiar with the printmaking of the seventeenth century, with the work of Rembrandt and other Northerners, and with that of Stefano della Bella, Salvator Rosa, Castiglione, and other Italians.

The years around 1740 saw a great resurgence of etching among Venetian artists. Tiepolo and Canaletto became for a while deeply involved with it, and even Piazzetta tried a couple of small plates. Canaletto saw etching as an opportunity for free inventiveness and experiment, and his prints were clearly much appreciated in the circle of Consul Smith and were handsomely published between Smith's appointment as consul in June 1744 and Canaletto's departure for England in 1746.[14] Giambattista was also taken with enthusiasm for the medium at the same time and quickly produced the twenty-two plates known as the *Scherzi di fantasia* (cat. nos. 55–63). Oddly enough, these do not appear to have given rise to any corresponding appreciation and were never published in any systematic and definitive fashion. However, they evidently appealed to Anton Maria Zanetti, a prominent connoisseur, and himself active in the revival of the chiaroscuro woodcut. He appears to have commissioned a further ten plates from Giambattista, known as the *Vari Capricci* (cat. nos. 42–51). He quickly took possession of them and began to insert the ten etchings in volumes of his collection of chiaroscuro woodcuts after Parmigianino, the *Diversarum iconum*, as they were made up for clients. One such volume bears the date 1743.[15]

To place the *Scherzi di fantasia* before the *Capricci*, as is maintained here, runs against the conventional wisdom, but I am sure that it is the only logical possibility.[16] The series of preparatory drawings for the etchings in the Victoria and Albert Museum offers no distinction in style or date between those for one set and the other.[17] Some light is thrown on this question by the two drawings at Philadelphia (cat. nos. 65 and 66), which, while they are not actual studies directly associated with the *scherzi*, nevertheless suggest that he was beginning to become involved with that thematic material in the later 1730s.[18] The *scherzi* present a quite varied and experimental pattern of development in subject matter and style, whereas the *capricci* are completely confident and consistent, and relatively free in handling. Furthermore, the *scherzi* can be arranged in a convincing order of execution leading toward the manner of the *capricci*, and many of the first proofs of both sets are worked over in pen by Giambattista to indicate possible improvements. These are only transferred to the plates in the case of the *scherzi*: evidently Zanetti took possession of the *capricci* before Giambattista had had an opportunity to revise them.[19]

However, these are questions for the specialist. What is of more concern here is the pattern of ideas that lies behind the etchings, and these have been much discussed.[20] It is clear that Giambattista is drawing on material in the prints of Salvator Rosa and Castiglione. This is very evident in the large drawing from the Peter Jay Sharp collection (cat. no. 63), which owes so much to Salvator; it is also clearly linked with *Scherzo 22* (cat. no. 62), one of the last of the series, looking forward to the *capricci*. In these "fantastic jokes" Tiepolo's imagination finds a refuge in a vague environment of arcadian antiquity inhabited by magicians and satyrs. Like many people today living in a materialistic and tightly controlled environment, he wants to flee to a simple, primordial world closer to the pulse of nature. His old magicians instructing youth are the forerunners of Don José and the aspiring Castaneda, probing deeply into the secrets of living things, with skulls littering the ground as a reminder of the transience of life. The only comparable project that is in any way contemporary is that undertaken by Anton Maria Zanetti, Giambattista's friend and patron, who in the later 1750s became involved with Gaetano Zompini in the production of a set of twelve etchings after drawings by Castiglione.[21] Several of these etchings, folio in size, depict the centaur Chiron devoting himself to the education of the young Achilles, not of course in the arts of war—that would have been quite contrary to the intentions of Thetis, the boy's mother—but in music, poetry, and the magic arts.

At this same time Domenico, now aged sixteen, also became involved in etching, perhaps as an essential part of his education. Many of his prints record the notable works of his father of the same period (cat. no. 19b). Thus we find him making a series of reproductive etchings after his father's Tasso cycle, almost certainly painted in 1742 for Ca' Manin, the great Sansovino palace on the Grand Canal near the Rialto, now the Banca d'Italia. Etching remained an important part of Domenico's activity for perhaps some fifteen years. His *Raccolta di teste*, a series of sixty small etchings recording

sometimes the series of "Philosopher portraits" by his father, sometimes notable details taken from his paintings and sometimes his drawings (cat. no. 19a), constitute a little monument to Giambattista's achievement.

SOLE FIGURE VESTITE

While some of the albums of pen drawings by Giambattista contain compositional studies for paintings, these are often buried in groups of similar drawings which can be described as variations on a theme. Other albums have virtually no links at all with the painted works. Such is the album entitled *Sole figure vestite* in the Victoria and Albert Museum, with 89 studies of single dressed figures, and another similar volume, which has been dispersed. The possible contents of the latter run to about 100 items (cat. nos. 15–18). Some 30 additional specimens can be counted which do not come from this source, together with 21 in the Sartorio collection. Thus we have record of about 240 drawings of "single dressed figures," not all of them old men but predominantly so. These figures, floating on the page, are creatures of Tiepolo's imagination, bearing no link with anything directly experienced: their faces often hidden, often turning away, vanishing again like insubstantial ghosts into the nothingness from which they emerged.

The Tiepolo caricatures have a little more substance (cat. nos. 25–29), but the essence of caricature is personality, and strangely these have none. They are not real people, seen on the streets of Venice, much less friends and acquaintances, as in the caricatures of Zanetti or Ghezzi, but strangely abstract symbols recollected in tranquility. Only at very rare moments does one feel that Giambattista is responding immediately to something seen: this seems to be true of the study of an old couple in the Metropolitan Museum of Art (cat. no. 25) and in the celebrated Wildenstein family group (fig. 12). The latter seems to have some links with the landscape drawings, where again Giambattista was demonstrably looking at real buildings.[22]

DOMENICO TIEPOLO: SCENES OF CONTEMPORARY LIFE

Domenico's pen drawings can be divided into two broad categories, religious and secular. They are also very much dominated by the factor of scale. The full folio sheet is reserved for large monumental statements, essentially the three great series of finished drawings—the *Large Biblical Series*, the *Scenes of Contemporary Life*, and the *Divertimento per li regazzi*—but there are a few other examples, essentially some of the crowd scenes drawn in pen alone, which are also full folio. Most drawings of any elaboration are quarto-sized, simply the folio sheet folded in two; smaller drawings, usually of one figure only, are octavo-sized—the quarto sheet folded in two.

The smaller religious drawings, often running in long series and leading up to the *Large Biblical Series*, do not concern us here, but the smaller secular drawings likewise lead up to the *Scenes of Contemporary Life*. One such quarto-sized secular drawing (cat. no. 38) exemplifies very well the way in which Domenico treated his images. The sheet

FIG. 13. *Giovanni Battista Tiepolo,* A Peasant Family on the Way to Church. *Pen, ink, and wash over chalk, 37.9 × 50.7 cm. Peter Jay Sharp Collection, courtesy National Academy of Design, New York*

shows a country scene, a woman with a distaff standing in front of a sleeping man. In fact this drawing is a composite image of two earlier drawings by Domenico,[23] which in turn derive from etchings by Nicholaes Berchem and Cornelis Bloemaert. The woman with a distaff is used again in one of the *Scenes of Contemporary Life* at Bayonne, *The Swineherd*, but the sleeping man reappears in at least four of Domenico's later large drawings, twice in the *Large Biblical Series* of the Recueil Fayet in the Louvre,[24] and twice in the *Divertimento*.[25]

This habit of reusing old material seems strange to us, with our passion for originality, though it would not have seemed strange to Bach or Handel. Domenico, I would suggest, felt that the visual material accumulated by his father and himself over the years was an image bank on which it was appropriate to draw as occasion offered. The eighteenth century, no less than those before it, valued quotation, preferably from the classics, but any source that would reflect on the taste and erudition of the user would suffice. Likewise, the connoisseur was a man who could derive pleasure

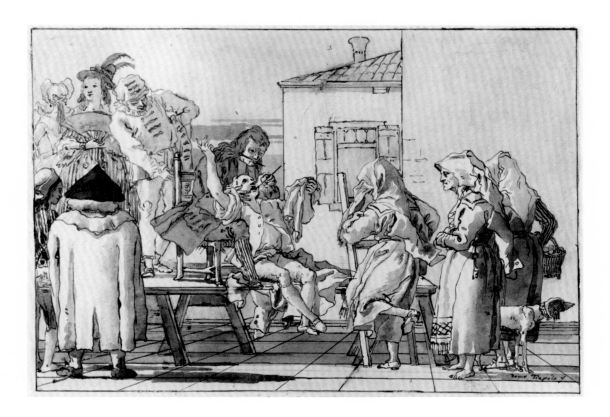

FIG. 14. *Giovanni Domenico Tiepolo,* The Quack Dentist *(also called* The Mountebank*).*
Brown ink and gray and brown washes over traces of black chalk, 37.1 × 50.3 cm.
Philadelphia Museum of Art, Purchased with funds from the SmithKline Beecham
(formerly SmithKline Beckman) Corporation for the Ars Medica Collection

from an obscure reference, since it became a sort of gracious compliment to his own taste and erudition.

The *Scenes of Contemporary Life* fall into a number of well-defined groups.[26] Although the arrangement of these groups must be fairly arbitrary, perhaps one may consider first a series of scenes of peasant life, of which *A Peasant Family on the Way to Church* (fig. 13) is a representative example. Here, as in a number of the drawings, the setting is taken from a landscape drawing by Giambattista. In this case the original is lost, but we have several other views of this range of buildings from different angles,[27] which may be identified as the church of Santa Maria delle Grazie at Udine. Then follow a series of diversions in the countryside, such as *The Mountebank* (fig. 14). The charlatan was a familiar figure in the villages and towns of the Veneto and represented a regular form of open-air theater. One of the most celebrated was Bonafede Vitale, an erstwhile academic of copious memory, who could discourse on any topic, pull teeth without pain, and work marvelous cures with a mixture of Cyprus wine and

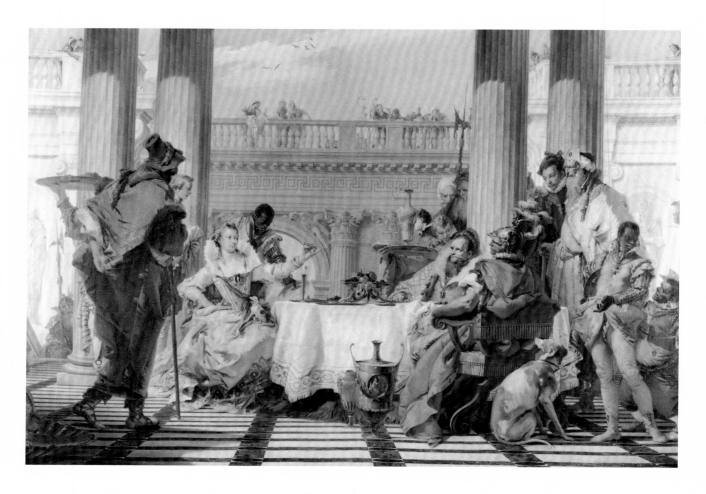

FIG. 15. *Giovanni Battista Tiepolo,* The Banquet of Cleopatra.
*Oil on canvas, 248.2 × 357.8 cm. National Gallery of Victoria,
Melbourne, Australia, Felton Bequest, 1932*

lady-apples. A far less attractive character is the professional doctor (cat. no. 40), whose incompetence is declared by his asses ears. Finally, we are able to join in the good life of Venice. *A Venetian Banquet* (cat. no. 39) is hardly less magnificent than the fabulous *Banquet of Cleopatra* (fig. 15) of Giambattista at Melbourne, while *The Card Players* displays a more simple and decorous Venetian scene. Many of these scenes make a free use of the caricatures of Giambattista and Domenico, but some of these drawings are caricatures in themselves, such as the *Presentation of the Fiancée* (fig. 16), clearly making fun of bonnets and the exaggerated social behavior of the day.

But on the whole the satiric mode is alien to Domenico, and the characters and the situations of the *Scenes of Contemporary Life* are treated with gentle affection. Many of the drawings are dated 1791. It is possible that many of the scenes of country life, which do not bear the date, are somewhat earlier, and some of the more elaborate Venetian scenes, again not dated, show fashions in dress that are more typical of the closing years

of the eighteenth century. So just as the *Large Biblical Series*, which may be generally dated about 1785, shows signs of having taken some years to complete, so the *Scenes of Contemporary Life* may be spread over several years before and after 1791—an ominous year in European history—the year of the flight to Varennes. But these events had yet to cloud the sunny skies of the Veneto.

DIVERTIMENTO PER LI REGAZZI

The closing years of Domenico's life were occupied with a project that both complements and provides contrasts to the earlier series. Our speculations about the *Divertimento per li regazzi* (cat. nos. 36 and 37) rest on much surer foundations than the set that precedes it. First of all, we have Domenico's title page (fig. 17), which gives us a title and an indication of the total number of drawings in the series—104—and it seems that we lack a visual image of only one of these. Next, the title page establishes the leitmotiv of the series, the factor that relates Domenico's Punchinello to that of his father: the Veronese festival of *venerdì gnoccolare*.[28] Giambattista's Punchinello drawings go back at least to the 1730s and continue until the eve of the departure for Spain. They were very much appreciated by Count Francesco Algarotti, who claimed to have twelve of "les plus belles policinelles du monde," and something of this may be reflected in the two etchings by Georg Friedrich Schmidt of 1751 (cat. nos. 33 and 34). This very specific character is also the subject of two paintings and he appears in two of the *Scherzi*. It is very seldom that Giambattista's figure is not associated with the cooking and eating of gnocchi, which was the essential element of "gnocchi-eating Friday." On this day, the last Friday in Carnevale, the poor boys of San Zeno would dress up in white, with white sugar-loaf hats and masks, and *piva in gola*, a sort of whistle in the throat which reduced speech to a cackling noise. Reciting macaronic verse specially written for the occasion, they would have audience with the *podestà*, or mayor, and invite him to join in the festivity. He would accept and graciously come down to the Piazza San Zeno, where he would be offered a dish of gnocchi and a glass of wine. These formalities over, the eating and drinking would go on until few people could stand up. Giambattista's Punchinello is often short and fat, but Domenico's, who only intermittently displays an appetite for gnocchi, is young and lean, almost athletic in body, despite the hunchback. Neither Punchinello is the gross, cruel Punch of the Punch and Judy show. Domenico's Punchinello, who does not emerge until the last stages of his career, is Everyman, from Alexander the Great to the poorest peasant, sometimes both the flogger and the flogged, both the firing squad and the poor corpse riddled with bullets; most of the time he is a fairly prosperous Venetian enjoying his rich and peaceful inheritance.

Punchinello is also a character from the theater in the tradition of the *commedia dell'arte*, a theater of the streets which avoided scripts and encouraged the characters to extemporize, to embroider wildly on whatever might take the fancy of the audience. So the question arises as to whether the *Divertimento* has any script or story line. Here

FIG. 16. *Giovanni Domenico Tiepolo*, Presentation of the Fiancée.
*Pen, ink, and wash over chalk, 37.1 × 49.9 cm. The Thaw
Collection, The Pierpont Morgan Library, New York*

it must be noticed that Domenico took the trouble to number the drawings, and although the sequence he proposes is often disregarded, it does by and large provide a quite coherent story line. These numbers are found in the top left corner of the sheet and are often concealed by the mount, and they are not shown in the set of photographs of the series made by Richard Owen before the dispersal of the drawings began. However, the three known sets of the photographs are themselves numbered in pencil, but not in a very consistent manner. This itself is odd, and the only logical explanation is that Owen himself was experimenting with variations in the sequence and marking the photographs to record his results. The pencil numbers of the set currently with Sir Brinsley Ford coincide pretty exactly with Domenico's numbers wherever these are recorded, and so these two series provide a reasonably authoritative sequence.[29] In this sequence the drawings here exhibited are numbers 4 and 40.

The story of Punchinello begins, as any good biography should, with some account of the family background, and the birth of Punchinello's father, hatched from a monstrous turkey's egg. It passes over entirely the youth and upbringing of the father but describes his courting and marriage, which is a very grand affair, echoing that of Frederick Barbarossa and Beatrice of Burgundy in the Kaisersaal at Würzburg. After the

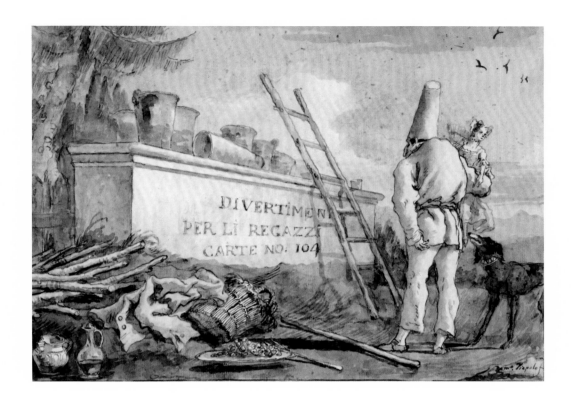

FIG. 17. *Giovanni Domenico Tiepolo,* Title Page—Divertimento per li regazzi.
Brown ink and wash, 29.2 × 40.6 cm. The Nelson-Atkins
Museum of Art, Kansas City, Missouri (Purchase: Nelson Trust)

wedding, Punchinello's father brings home his bride, number 4 of the series (cat. no. 36), to be welcomed by the old mother, the Saint Anne of the *Large Biblical Series*. Then follows *The Wedding Banquet*, number 5 of the series (fig. 18), which is entirely derived from *A Venetian Banquet* of the *Scenes of Contemporary Life* (cat. no. 39), though it harks back to Giambattista's *Banquet of Cleopatra* (see fig. 15). Sadly, our group of drawings must now jump the birth and upbringing of Punchinello in a simple but decent Venetian home, drawings in which Domenico may well be recalling his own childhood, and enter the perils of adolescence, which, as so often happens today, involves a brush with the law. Our hero appears before the magistrate, number 35 of the series (fig. 19). However, someone is taking account of a written plea, *grazia a Pocich/nela*, and the magistrate does not appear to be taking too grave a view of the situation, and so young Punchinello is let off with a warning. Soon, Punchinello is carried in triumph in a procession, number 37 of the series (cat. no. 37), waving a piece of gnocchi on a fork, and soon after this he settles down to earn his living. As the series advances, he becomes a man of substance, and we see Punchinello as a portrait painter, number 70 of the series (fig. 20), no less a person than Apelles with Alexander at his elbow. The last phase is a sad one: Punchinello falls sick and is attended by the same incompetent

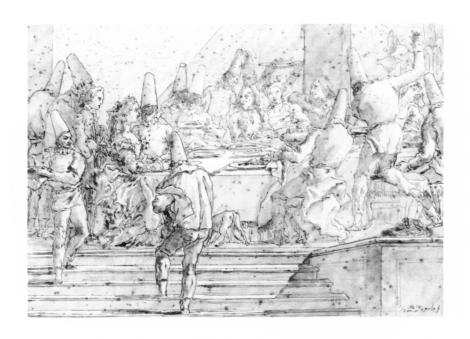

FIG. 18. *Giovanni Domenico Tiepolo,* The Wedding Banquet.
*Pen, ink, and wash over chalk, 35.4×47.2 cm. The Thaw
Collection, The Pierpont Morgan Library, New York*

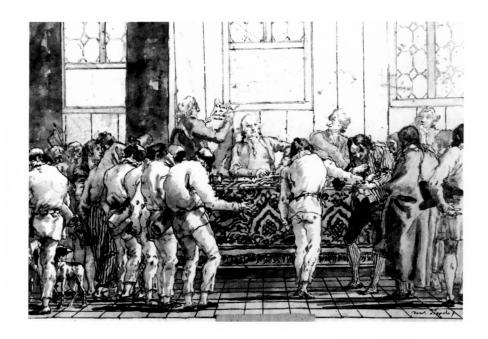

FIG. 19. *Giovanni Domenico Tiepolo,* Punchinello before the Magistrate.
*Pen and brown ink, brush and brown wash, over black chalk,
34.8×60.5 cm. © The Cleveland Museum of Art, 1996, Purchase
from the J. H. Wade Fund, 1937.569*

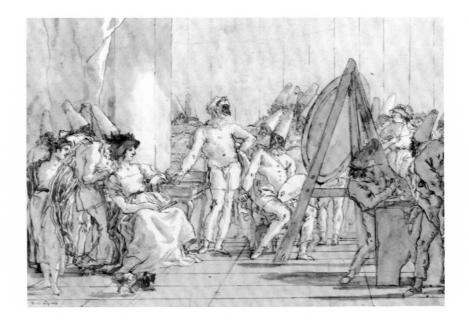

FIG. 20. *Giovanni Domenico Tiepolo,* Punchinello as a Portrait Painter.
Pen, ink, and wash over chalk, 29.2 × 41.4 cm. Private collection,
courtesy of Hazlitt Godden & Fox Limited

ass of a doctor whom we have seen before (cat. no. 40). Then Punchinello falls sick by the roadside, number 83 of the series, surely a "Descent from the Cross" no less than *The Death of Wolfe,* and after various other miseries and misfortunes, he dies.

These were sad days for Venice, too. Domenico lived to see, as a man of seventy, the collapse of the *Serenissima*, that most serene Republic of Venice which had nurtured him and his father and had bestowed on them prosperity and fame. He was a man of the ancien régime and could have had little sympathy for the modern world, blood-stained and brutally oppressive, which was then being born, and in which we still manage, somehow, to survive today.

NOTES

1. For much new information about the circumstances of Giambattista's family and his up-bringing, and about the problems of inheritance following his death, see Federico Montecuccoli degli Erri, "Giambattista Tiepolo e la sua famiglia: nuove pagine di vita privata," *Ateneo Veneto* 32 (1994): 7–42.
2. London, Victoria and Albert Museum (2 albums); New York, The Metropolitan Museum of Art (the Biron Album); New York, The Pierpont Morgan Library (the Fairfax Murray Album); Florence (the Horne Album); Trieste (the Sartorio Collection).

3. The Orloff Album: sale, Petit, Paris, 30 April 1920; the Kay Album: "Tomo terzo di Caricature," sale, Christie's, London, 8–9 April 1943.

4. The Beurdeley Album in the Hermitage, St. Petersburg; and the "Quaderno Gatteri" in the Museo Correr, Venice.

5. Sale, H. G. Gutekunst, Stuttgart, 27 March 1882. The catalogue is reproduced in *Tiepolo: Zeichnungen von Giambattista, Domenico und Lorenzo Tiepolo* (Stuttgart: Graphische Sammlung, 1970), p. 198.

6. Sale, Christie's, London, 15 June 1965.

7. Sale, Petit, Paris, 30 April 1921.

8. Sale, Rahir, Paris, 31 May 1920.

9. Sale, Sotheby's, London, 6–7 July 1920, lot 41; Colnaghi's; Richard Owen, Paris.

10. Vigni 1972, nos. 8–22; Victoria and Albert 1975, no. 14.

11. George Knox, "Francesco Guardi as an Apprentice in the Studio of Giambattista Tiepolo," *Studies in Eighteenth-Century Culture*, vol. 5, ed. Ronald Rosbottom, pp. 29–39 (Madison: University of Wisconsin Press, 1976). Christel Thiem, "Lorenzo Tiepolo as a Draughtsman," *Master Drawings* 32, no. 4 (1994): 315–50, nos. 2–10—in my opinion the Weimar drawings are by Francesco Guardi and the Florence, Bardini, drawings are by Raggi.

12. Filippo Pedrocco, "Giambattista Tiepolo: illustratore di libri," in Gorizia 1985.

13. M. Brunetti, "Un eccezionale collegio peritale: Piazzetta, Tiepolo, Longhi," *Arte Veneta*, no. 5 (1951): 158.

14. Ruth Bromberg, *Canaletto's Etchings* (London, 1974; San Francisco: Alan Wofsy Fine Arts, 1993), p. 22.

15. Maria Santifaller, "Karl Heinrich von Heineken e le acqueforti di Giambattista Tiepolo a Dresda," *Arte Veneta* 26 (1972): 145–53.

16. For a full discussion, see Knox 1972. The most recent presentation of the alternative view is by Dario Succi in Gorizia 1985.

17. Victoria and Albert 1975, nos. 102–29.

18. See Cambridge 1970, no. 17.

19. Washington 1972, pp. 14–22.

20. Most recently by Thiem, "Lorenzo Tiepolo as a Draughtsman," p. 322.

21. Maria Santifaller, "Un problema Zanetti-Zompini in margine alle ricerche Tiepolesche," *Arte Veneta* 27 (1973): 189–200.

22. George Knox, *Un quaderno di vedute di Giambattista e Domenico Tiepolo* (Venice: Electa Editrice, 1974).

23. Heygate Lambert sale, Sotheby's, London, 21 April 1926, lot 31c; provenance unknown, Sotheby's, London, 28 June 1928, lot 6.

24. No. 42 of the series, *St. Peter Visited by the Angel in Prison*. The main group there derives from a drawing in the Orloff Album, no. 140; no. 118, *An Angel Urging the Prodigal to Return to His Father*.

25. No. 42 of the series, *The Dromedary and the Traveller Resting*, whereabouts unknown; no. 92 of the series, *The Garden with Statues*, Providence, R.I., John Nicholas Brown; Gealt 1985, nos. 89 and 35.

26. For a full checklist see the catalogue *Domenico Tiepolo: Master Draughtsman* (Udine, 1996), which presents twenty examples—nos. 135–54.

27. Knox, *Un quaderno di vedute*, nos. 33, 52, 53, and 69.

28. Knox 1984.

29. A checklist in this sequence is provided in *Domenico Tiepolo: Master Draughtsman* (see n. 26), which presents twenty-two examples—nos. 155–76.

Catalogue

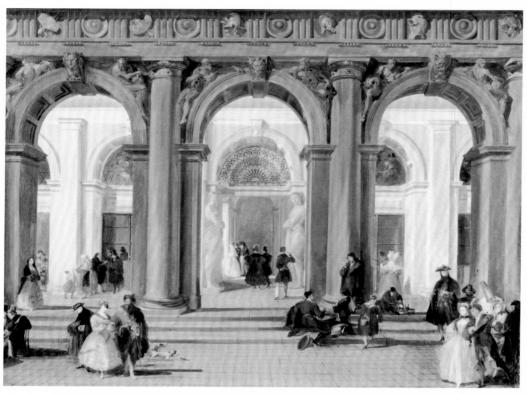

1.

Masked Society

1. Giuseppe Bernardino Bison
 Italy, 1762–1844
 The Entrance to the Biblioteca Marciana, Venice
 Oil on canvas
 54 × 72.4 cm
 Private collection, courtesy of Pyms Gallery,
 London

A set designer by trade, Bison clearly draws on his familiarity with theatrical staging in this marvelous set piece on the subject of masking, display, and public ritual.

The setting is one of Venice's treasures, the Marciana Library, the foundation of which was the extensive library of the Byzantine expatriate Cardinal Bessarion, Orthodox archbishop of Nicaea, who bequeathed it to his adopted city. The origin of the Marciana itself speaks to Venice's privileged position in the eighteenth century, midway between East and West in terms of trade and cultural exchange. This bringing together of cultures is certainly at the core of the contradictory impulses toward control and freedom, toward self-restraint and the masked freedom of Carnevale explored by this exhibition.

Scattered throughout the library's entrance are several fruit sellers and vendors; a group of figures familiar from the *commedia dell'arte* who figured then, as now, so prominently in the celebration of Carnevale, including the ubiquitous figure of Punchinello, can be seen at the right. On the left, a pair of seated tourists (identifiable as such by their clothing) lounge; to their right, a Venetian couple in costume (the man's costume makes another reference to the East) are followed by the sinister-looking figure of a man in the black cloak known as the *domino*. The entrance to the Biblioteca that Bison has described thus includes a cross section of Venetian society, incorporating figures that bridge divisions of social class and nationality. These figures represent a kind of staged setting for the life of the city, ranged across what is almost but not quite literally a stage—albeit a stage of extraordinarily classical, theatrical grandeur. Combining the masked and the unmasked, the diminutive and the immense, the static and the movemented, Bison's painting is an image of great artifice that captures something of the energy and decay that equally characterized the city in one of its last moments of cultural flourish.

— J.C.S.

2. Etched mirror

Italy, early eighteenth century
Polychrome and gilt with etched glass
213.4 × 109.2 cm
Antonio's Antiques, San Francisco

The Venetian glass industry, one of the earliest to be established and at one time a lucrative monopoly of the Republic, began to decline in the eighteenth century in part because of increased foreign competition from Silesian, Bohemian, and French factories. The refusal by eighteenth-century Venetian glassmakers to depart from the traditional designs that had previously met with great success may have been another factor contributing to this decline. Moreover, the lack of innovation (by contrast to the other Venetian arts of the settecento) has made the identification of certain types of eighteenth-century Venetian glass problematic. However, the inclusion of etched figures like the one in this mirror, which resembles characters typically found in works such as those in catalogue numbers 7–12, makes this mirror recognizably eighteenth century—although it may have been made in Sicily to a Venetian design.

The delicate, intricate design of the floral motifs and scrolls, and the use of color and gilt on this mirror reveal the pleasure that Venetians took in the embellishment of common objects. Considering its impressive size and the high cost of glass at that time, this mirror would have served as a symbol of status and wealth in the home of a rich nobleman. What is most striking about the mirror, however, is neither the beauty of its design nor its immensity; rather, it is the presence of the etched figure in *domino* (a short, black, hooded cloak), tricorn hat, and mask in the center of the glass. Venetians spent almost half the year—from October to February—in costume, wearing the *domino* and mask like the figure etched in the mirror. The identity of the eighteenth-century Venetian looking in the mirror is thus doubly masked: probably already wearing the costume of Carnevale, the subject then gazes not into his own reflection but into a representation of the appearance he has assumed. The anonymity that resulted from a society whose citizens disguised their identity with masks and costumes induced Venetian citizens during the period of Carnevale to act outside the traditional boundaries of acceptable behavior and indulge in the freedoms that anonymity afforded.

– D.Z.

2.

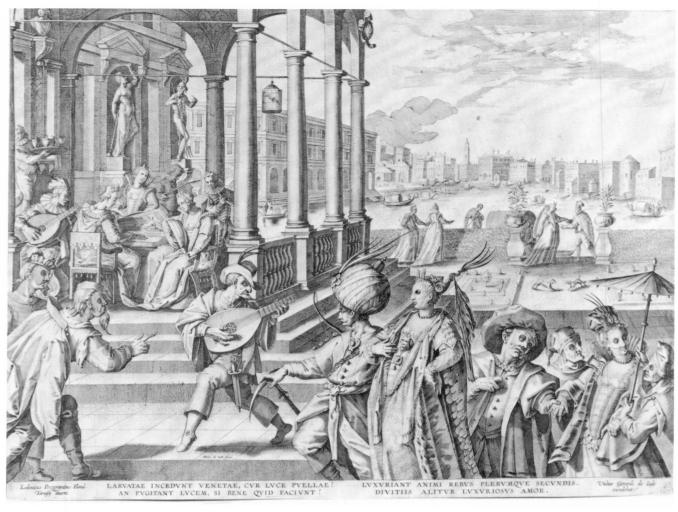

3.

LARVATAE INCEDVNT VENETAE, CVR LVCE PVELLAE! LVXVRIANT ANIMI REBVS PLERVMQVE SECVNDIS.
AN FVGITANT LVCEM, SI BENE QVID FACIVNT? DIVITIIS ALITVR LVXVRIOSVS AMOR.

3. Peeter I de Jode
Flanders, ca. 1570–1634
Venetian Carnival
after Lodovico Toeput (Flanders, 1550–1605)
Engraving
36.8 × 49.9 cm
The Metropolitan Museum of Art, The Elisha
Whittelsey Collection, The Elisha Whittelsey Fund,
1951. (51.501.1653)

PROVENANCE: Liechtenstein Collection

The Flemish engraver de Jode produced this print
in the early part of the seventeenth century. This
highly mannered engraving after a work by an-
other seventeenth-century artist from Antwerp,
Lodovico Toeput, who lived and worked in Italy,
lends a multifaceted historical perspective to repre-
sentations of Venetian Carnevale. While it shows
masked figures engaged in the delights of the festi-
val, the image simultaneously provides a city view
in the background similar to the popular *vedute*,
or views, which were to become prevalent among
eighteenth-century representations of Venice. The
view of a lagoon—complete with canals, build-
ings, and gondolas—establishes the Venetian con-
text. A procession of masked, dramatically posed,
and opulently dressed figures makes its way across
the foreground and up the stairs of a neoclassical
palazzo, where a group of figures play music. A
lute player entertains these magnificently dressed
aristocrats, while in the right foreground a pair of
jesters attends to the parasol of an elegant, masked
woman. The intermingling of classes was a typical
occurrence within the public space of Carnevale,
where masks might have served as a leveling de-
vice. In this engraving, however, class differences
are reinforced: the elaborate costumes and con-
descending attitude of the patricians contrast
with the jesters and lute player who, dressed
more plainly, seem to be at once catering to and
mocking the aristocrats.

– Y.Y. & D.Z.

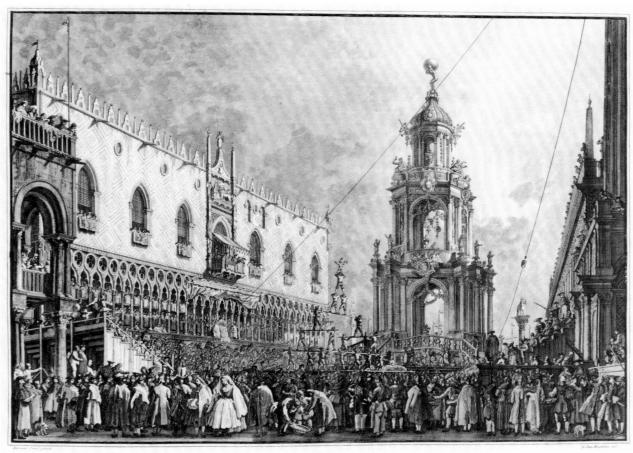

Die Jovis postrema Bacchanaliorum Serenißimus Princeps e ducali Palatio conspicit populares ludos, perantiquae victoriae monumenta

N. 7

4.

4. Giovanni Battista Brustolon
Italy, b. 1726
Coronation of the Doge, plate 7 from the series *Feste ducali* (Ducal festivals)
after Canaletto (Italy, 1697–1768)
Engraving
44.7 × 56.8 cm
The Metropolitan Museum of Art, The Elisha Whittelsey Collection, The Elisha Whittelsey Fund, 1961. (61.532.7)

The engraver Giambattista Brustolon was commissioned to make prints after twelve drawings by Canaletto illustrating the various festival rites and ceremonies in which Doge Alvise IV Mocenigo had taken part following his coronation in 1763. This print, the seventh of the group, depicts a public festival in the piazzetta just outside the ducal palace occurring on the last Thursday of Carnevale. That holiday traditionally spawned wild and indulgent behavior reminiscent of a pagan bacchanal. Many members of the crowd can be seen wearing the *domino* with a tricorn hat, one of the most common costumes worn during Carnevale. The *domino* was a short black cloak with a hood worn with the mask known as the *bautta*; together, the two were seen repeatedly in representations of eighteenth-century Venetian social life. The doge's presence in the festival is recorded as he watches the acrobats from the balcony of his palace. The print describes an exuberant Venice in which the piazzetta is transformed into an outdoor stage around which the crowd gathers to share, along with the doge, in the spontaneous entertainment that Carnevale offered.

– D. Z.

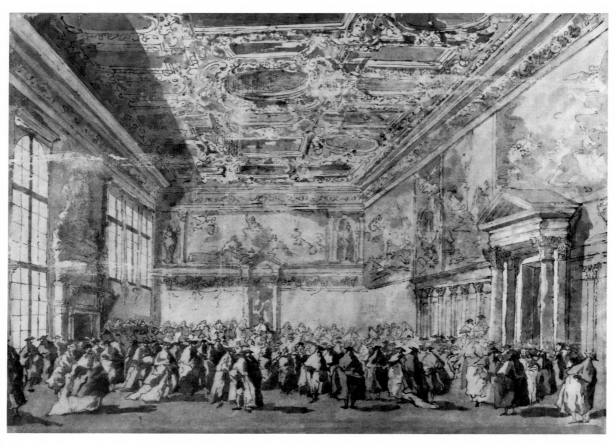

5.

5. Anonymous

Italy, nineteenth century
The Doge of Venice Receiving Ambassadors in the Sala dei Collegio
after Franceso Guardi (Italy, 1712–1793)
Pen and brown ink and wash over traces of graphite on laid paper
35.1 × 47.9 cm
Fine Arts Museums of San Francisco, Achenbach Foundation for Graphic Arts, Gift of Edmund B. MacDonald, 1965.49

PROVENANCE: Galerie Cailleux, Paris; Frank Schwabacher, Jr., San Francisco; Achenbach Foundation for Graphic Arts, California Palace of the Legion of Honor, San Francisco

LITERATURE: Berkeley 1968, no. 39, as Circle of F. Guardi

This drawing derives from a series of twelve works depicting Venetian ducal ceremonies and festivals commemorating the coronation of the doge in 1763. The series, originally drawn by Canaletto, then engraved by Brustolon and painted by Francesco Guardi, conveys the heightened significance of pomp and ceremony during the second half of the eighteenth century, the period of Venice's fading glory.

In this work, the dominating linear perspective enlarges the pictorial space. A teeming mass of figures recedes into the vast architecture of the *sala*, or hall, further heightening the effect. Opulent displays of elegance and indulgence such as this functioned as a coping mechanism for the ailing Republic: as valued signs of wealth and control, they allowed the government to maintain illusions of well-being and stability. These illusions were further upheld through the facade created by a costumed and masked society that suggested a city free of troubles and a people concerned only with play. The traditional costume of the *domino* (a black hooded cloak), tricorn hat, and mask as worn by the figures in this image may function as a kind of uniform, although a uniform regulates behavior while a mask relaxes inhibitions through the anonymity it provides. The mask, both literally and figuratively, is a paradoxical object: in exchange for what it hides, it provides an opportunity to construct other identities out of pretense, make-believe, or the imagination, mechanisms which propel both theater and the visual arts.

The twelve representations of ducal festivals attest to the Venetian Republic's overwhelming

In Pesci e'il Sol, le rustiche fatiche
Sospende il freddo, e mascherate intanto

FEBRARO

L'alme ricrean con danze, suoni, e canto
D'egl'industri cultor le turbe amiche.

6.

emphasis on tradition and ceremony as it neared collapse. This doge's successor, the last in a line of 120 going back to the seventh century, claimed political neutrality. Recognizing Napoleon's victories in northern Italy, he abdicated power in 1797.

– Y.Y. & D.Z.

6. Francesco Bartolozzi
 Italy, 1727–1815
 Febraro
 after Giuseppe Zocchi (Italy, act. in England, 1711–1767)
 Etching and line engraving
 33.3 × 42 cm
 The Baltimore Museum of Art: Garrett Collection, BMA 1946.112.6609

One of a series of twelve engravings depicting the months of the year, *Febraro* presents a picturesque, rustic setting in which the end of winter is celebrated. February also heralds the coming of Lent and its accompanying privations: as the last month of Carnevale, it lends itself to the wildest excess and to the most gluttonous and frivolous amusements. The figures of Bartolozzi's engraving are appropriately preparing for a pre-Lenten feast; to the left a strangely empty table tended by an unmasked man stands waiting to be laden while a group of revelers arrives at the far right. The hunchbacked form of Punchinello with his characteristic conical hat can be seen among the group of dancers. The staging of the rustic celebration among ruins reinforces the message of rebirth and renewal in the midst of decay and death. Bartolozzi has subtly combined the delectation of Carnevale with the rigors of Lent, the beginning of February with its end.

– C.U.

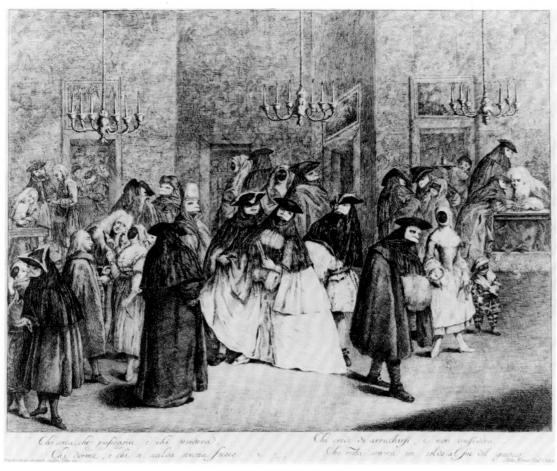

Chi cerca, chi passegia e chi sospira. Chi crede di arrichirsi, e non considera
Chi dorme, e chi a scalda senza fuoco Che resta senza un soldo al fin del giuoco

7.

7. Alessandro Longhi
 Italy, 1733–1813
 The Ridotto, ca. 1760
 after Pietro Longhi (Italy, 1702–1785)
 Etching
 39.8 × 46.8 cm
 Professor and Mrs. Lorenz Eitner, Stanford,
 California

 LITERATURE: Stanford 1980, p. 36, no. 64

This etching, probably from about 1760, repro-
duces a painting by Alessandro's father, Pietro
Longhi. The Ridotto, the public gambling house
of Venice, was among the most frequently de-
picted interior scenes in Venetian eighteenth-
century painting. It was one of Pietro Longhi's
favorite themes, and he painted several versions
with slight variations; the one on which this is
based itself probably derives from a painting by
Francesco Guardi. The masked woman in the cen-
ter with her slightly bent head is present in at least
ten of Pietro's paintings. Her pose is similar to
that of the unmasked courtesan in *The Minuet*
(cat. no. 35).

 Like the *Bal masqué* (cat. no. 10), this etched

scene offers a look into Venetian masked society,
in which masks were worn for nearly half the
year. The scene takes place in the main room of
the Ridotto. In this *salotto*, or sitting room, Vene-
tians assembled to socialize, gamble, and engage
in various flirtations and intrigues. The gambling
house originated in 1638, but following regulation
in 1704 only the nobility were permitted to hold
the bank and enter unmasked. The gamblers, on
the other hand, had to come dressed in *domino*.
The *domino* was a hooded cloak that covered the
head and fell below the shoulders. The disguise
was completed with a tricorn hat and mask over
the face. Women wore the oval *moretta*, a full face
mask with a button on the inside that was held
between the teeth, forcing a silence that intensi-
fied the mystery of the already unrecognizable
women. As one of the most intriguing public
spaces of eighteenth-century Venetian social life,
the Ridotto in many ways captures the qualities
of disguise, public spectacle, and ritual that were
central to Giambattista Tiepolo's world.

 – D.Z.

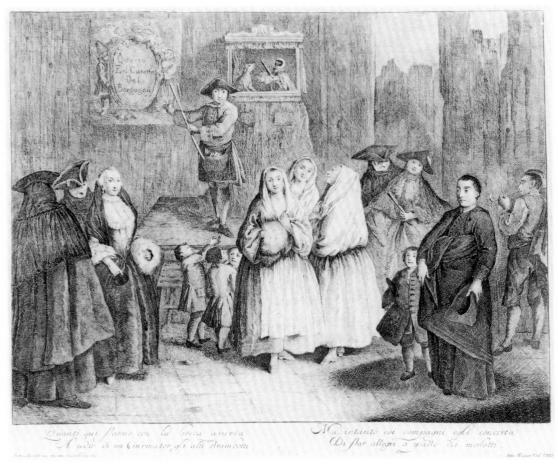

8.

8. Alessandro Longhi

Italy, 1733–1813
Il casotto del Borgogna (also called *The Puppet Show*), ca. 1760
after Pietro Longhi (Italy, 1702–1785)
Etching
37.6 × 46.5 cm
Professor and Mrs. Lorenz Eitner, Stanford, California

In addition to Venice's large theaters (which, in the eighteenth century, outnumbered those in Paris), the city contained numerous places of popular amusement, as well as entertainments offered by strolling acrobats and puppeteers. Longhi's print, after a painting by his father, shows a modest version of one of these establishments, Borgogna's Marionettes, well known in its day. The audience is small but mixed: a priest, a fashionable aristocrat with her attendant, servant girls, children.

A painter in his own right (see cat. no. 10) as well as a biographer of living Venetian artists, Alessandro is perhaps best known for his etched reproductions of his father's paintings. He took great liberties, however, in making such copies, often adding figures or altering compositions as he chose. One important alteration here is the addition of the moralizing commentary: "Here they stand gaping, / listening to the satires of a swindler, / while he plans to be merry, with friends, / at the expense of the half witted."

Performers were often described as charlatans, dupers of the gullible public in the same league with quack doctors. The inscriber's term for half-witted—*merlotti*, literally, young blackbird—is often found in descriptions of masked figures wearing the *bautta*.

– J.C.S.

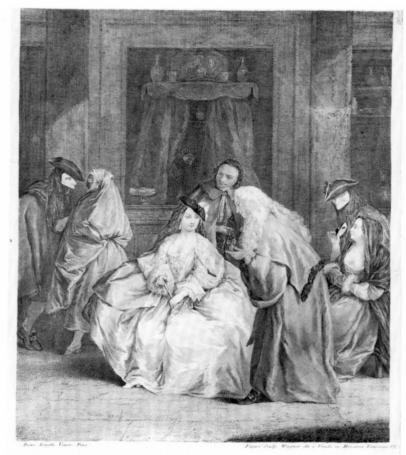

9.

9. **Charles-Joseph Flipart**
France, 1721–1797
Di degno cavalier tenera moglie, etc. (also called
The Meeting of the Procuratore and His Wife)
after a painting by Pietro Longhi (Italy, 1702–1785)
Engraving
45.2 × 36 cm
Fine Arts Museums of San Francisco, Achenbach
Foundation for Graphic Arts

This engraving of a painting by Pietro Longhi from about 1746 now at the Metropolitan Museum reveals fascinating details concerning the masked society that Venice had become in the eighteenth century. Maskers and their sometimes illicit behavior became a subject of great interest for Longhi who, by midcentury, began representing Venetians and their social life.

Flipart's engraving is one of a series of versions dealing with titillating interactions between couples. Here, the *procuratore*, a nobleman who held the bank at the Ridotto, or gambling house, is meeting his beautiful wife, probably within one of the many back rooms of the gaming house, where illicit activities were said to have taken place. Figures of unmasked *procuratori* were often seen in representations of the Ridotto (see cat. nos. 7 and 10). Following a regulation of the gambling house in 1704, only the aristocracy could hold the bank and enter unmasked.

Married women were accompanied everywhere by a *cavaliere servente*, a figure rather like a chaperone, selected by the husband immediately after the marriage. Sometimes he was her open and avowed lover, but more often he was her constant companion and guard. It is possible that the figure who hands the husband a set of keys is the wife's *cavaliere servente*.

The masked, flirting couples flanking the central figures amplify the erotic charge. The man on the left wears a *domino* (a short black cloak with hood and mask) and the woman's mask is known as a *moretta*. The *moretta*, worn only by women, was a black oval covering nearly the entire face. It was held in position by clenching a button on the inside between the teeth, which prohibited speech. This silence increased the power of mystery and seduction already induced by the anonymity created by the mask alone. By contrast, the woman on the right has revealed herself to her suitor.

– D.Z.

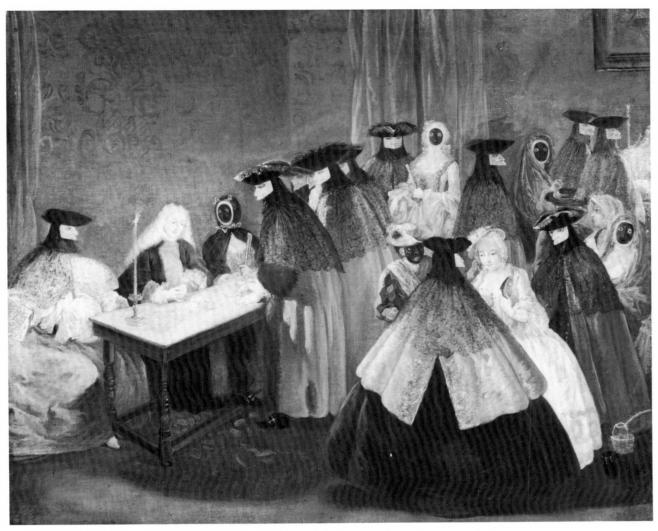

10.

10. Follower of Pietro Longhi
 (Italy, 1702–1785, formerly attributed to
 Alessandro Longhi, Italy, 1733–1813)
 Bal masqué
 Oil on canvas
 83.8 × 99 cm
 Fine Arts Museums of San Francisco, Gift of the
 late Lily Carstairs, Paris

Bal masqué depicts a scene familiar to eighteenth-century Venetians, who spent nearly half the year in the costume of Carnevale. The *domino*, the concealing cloak and facial covering that almost all of Longhi's figures wear, was the standard Venetian seasonal dress. The disguise varied according to gender. Men generally completed the ensemble with a tricorn hat and half mask featuring a prominent nose, while women more often wore the *moretta*. A woman kept the oval *moretta* in place by holding a button on the inside between her teeth, thereby making a mysterious silence compulsory.

The painting also depicts the Venetian passion for gambling: the seated and unmasked nobleman at the left deals cards to an engrossed group of men in *domino* and mask. Organized gambling was pervasive in eighteenth-century Venice. It first appeared in Venice in 1638 in the house of Marco Dandolo in the Calle del Ridotto (for which the *ridotti*, or gambling houses, were named) and subsequently came to be strictly regulated by the state.

Renowned for its permissiveness and diversions catering to every taste, Venice earned a reputation for licentiousness. The prevalence of costume that afforded the wearer anonymity was in no small part responsible for *La Serenissima*'s reputation as a dissolute pleasure ground. Longhi's proliferation of figures in *domino* re-creates the surreal quality of a clandestine society immersed in hedonistic pursuits.

— C.U.

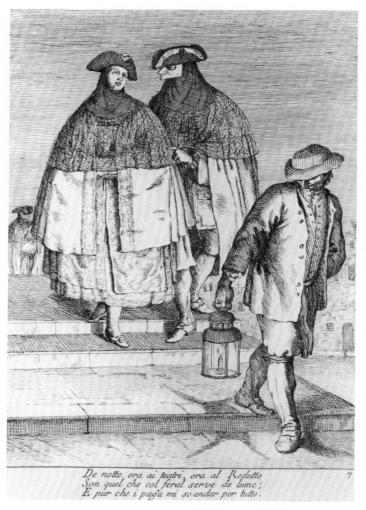

De notte, ora ai teatri, ora al Redutto
Son quel che col feral serve de lume;
E pur che i pagà mi so andar per tutto.

7

11.

11. Gaetano Gherardo Zompini
 Italy, 1700–1778
 Codega (Lantern Bearer), plate 7 of *Le arti*
 che vanno per via nella città di Venezia,
 published 1785
 Etching
 27.3 × 18.4 cm
 Rare Books Room, The Pennsylvania State
 University Libraries

12. Gaetano Gherardo Zompini
 Italy, 1700–1778
 Fitar Palchi (Keeper of Theater Boxes), plate 27
 of *Le arti che vanno per via nella città di Venezia*,
 published 1785
 Etching
 27.3 × 18.4 cm
 Print Collection, Miriam and Ira D. Wallach
 Division of Art, Prints and Photographs,
 The New York Public Library, Astor, Lenox and
 Tilden Foundations

In 1747 Zompini was awarded an official commission to create a book of engravings documenting Venetian tradespeople, following the success of similar books printed in Paris, London, and Bologna earlier in the century. Anton Maria Zanetti, the most notable collector in Venice, rescued the project from obscurity by publishing a new edition of Zompini's work in 1785, seven years after the artist's death. Each image from the 1785 publication is accompanied by a short text written in Venetian dialect by a friend of Zanetti.

In the *Lantern Bearer*, Zompini contrasts the voluminous figures of a dominoed couple making their way to the theater with the less visually significant figure of the lantern bearer who lights their way through the Venetian streets. The interaction of the masked man and his companion forms the image's focal point, and the subtle interplay of their gestures initially fastens the viewer's attention. As its title implies, however, Zompini's engraving is less concerned with the couple's

In piazza de S. Marco semo avezzi
Fitar palchi ogni sera in sie teatri
D'Opera, e de Comedia a varij prezzi.

27

12.

entertainment than with the work of their guide. The anonymity of the lantern bearer is striking: although unmasked, his downcast face remains hidden from view, obscured beneath the brim of his hat. With this device Zompini reminds us of the countless number of such figures who were necessary to maintain Venice's reputation as a center of pleasure and tourism, their labor ensuring that the apparatus of Venetian society was kept in working order. The representation of the lantern bearer jars the seamless picture of a city celebrated for its prosperity and frivolity and reveals the mechanism by which this facade was sustained. Zompini's sympathy for the city's working class is also expressed in the degree of dignity he allows his workman, who performs his office with a quiet composure.

In another of Zompini's engravings dealing with the daily lives of working-class Venetians, *Keeper of Theater Boxes* depicts a man plying his trade in the Piazza di San Marco. Shown conducting business with a couple in *domino* and mask, the workman's back is turned to the viewer, his profile marked in shadow. Although Zompini displays particular concern for the ordinary Venetians responsible for providing the entertainments and services for which the city was famous, he does not imbue them with distinct personalities and seems disinterested in bringing the individual to life. Emphasizing an enforced anonymity, he heightens awareness of the nameless multitudes whose labor ran the well-ordered machine that was Venice's pleasure industry.

– C.U.

13. Attributed to Louis-Joseph Le Lorrain
France, 1715–1759
Three Figures Dressed for a Masquerade, 1740s
Oil on canvas
166.4 × 127 cm
National Gallery of Art, Washington,
Samuel H. Kress Collection, 1961.9.92

PROVENANCE: Camille Groult, Paris (Groult sale, Paris, March 21, 1952, lot 84, as by Longhi); purchased by an anonymous dealer, France; sold by a French dealer to David M. Koetser Gallery, London and New York; by whom sold 1953 to the Samuel H. Kress Foundation, New York; gift 1961 to National Gallery of Art, Washington, D.C.

LITERATURE: Kress 1956, p. 190, no. 75, repro., as Venetian Master, Third Quarter of the XVIII Century, "Before the Masked Ball"; Washington 1968, p. 122, repro., as Venetian School, "Before the Masked Ball"; Kress 1973, pp. 175–76, fig. 338; Washington 1975, p. 362, repro., as Venetian School, "Before the Masked Ball"; Pallucchini 1976; Rosenberg 1978; Washington 1979, 1:186–87, 2: pl. 129, as Attributed to Fontebasso; Washington 1985, p. 420, repro., as Venetian 18th Century

Scholars have yet to solve definitively the mystery behind the authorship of this painting. Debate and discussion have surrounded its attribution since 1956, when the National Gallery first received the work on loan, and it continues to generate many questions concerning the circumstances behind its making. The uncertainty as to the artist's identity (and even nationality) adds a mystique to the work not unlike the mystique that surrounds a masker whose identity remains hidden. Could the artist, like the sitters he painted, be masquerading?

Most of the Italian artists to whom this painting has been attributed have been Venetian, although French, Polish, Austrian, and even Swedish artists have also been suggested. The Le Lorrain attribution, proposed by Pierre Rosenberg and accepted by the National Gallery in 1992, is the most recent in a long line of artists credited with this work. Rosenberg bases his argument primarily on the striking resemblance between the background architecture in this painting to that in a work by Le Lorrain purchased by the Louvre entitled *Architectural Caprice*. He further argues that the resemblance extends to the artist's palette and technique of painting with long, broad brushstrokes.

Despite Rosenberg's argument, reconsideration of an earlier claim made by Fern Shapley in the National Gallery's 1979 catalogue of paintings, which attributes the work to the great eighteenth-century Venetian painter Francesco Fontebasso, may be in order. Shapley bases this attribution on a compelling article published in 1976 by R. Pallucchini, a leading expert in eighteenth-century Venetian art. Pallucchini argues that Fontebasso may have painted this work during a two-year sojourn at the court of St. Petersburg in 1761 and 1762 and that the woman portrayed is Catherine II. The two courtiers in Polish costume might be identified as two gentlemen from among her court of favorites. Alternatively, their clothing might be seen purely as costume, like the mask the woman holds in her left hand. The setting in a grand neoclassical rotunda might readily suggest a Venetian setting or inspiration.

Scholars in the United States have had limited access to original Fontebasso paintings and thus have not been able to examine adequately the details of his technique, preventing Pallucchini's claim from receiving the consideration it deserves. In Pallucchini's opinion, Fontebasso was a versatile enough artist to produce such a painting in the grand manner celebrating the ritual of the masquerade.

– D. Z.

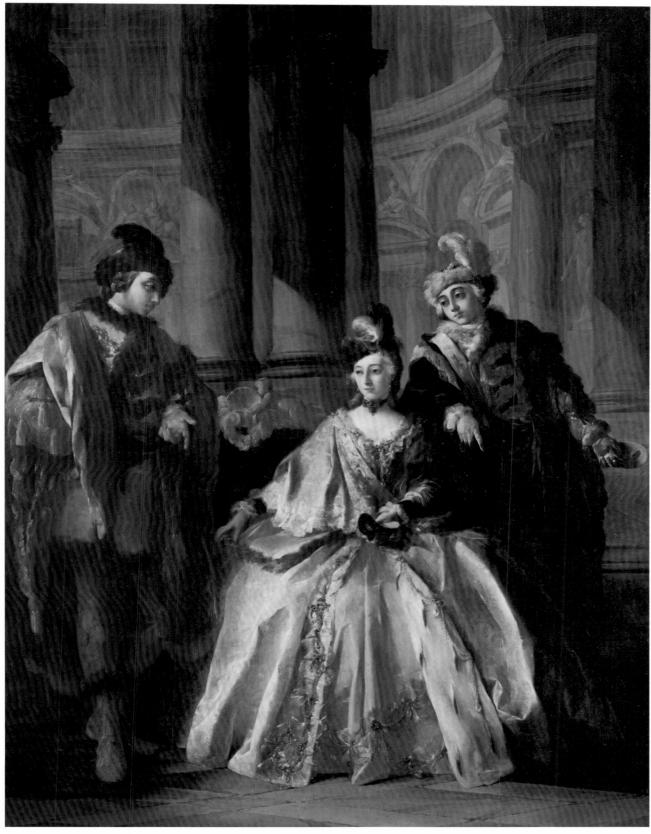

13.

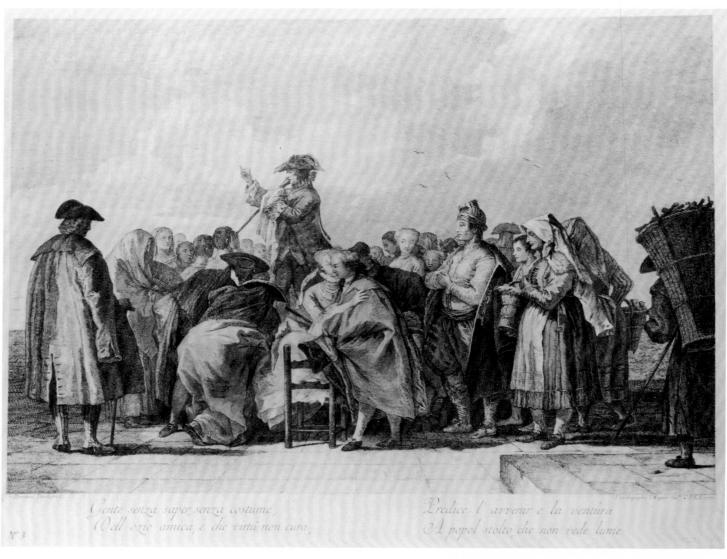

Gente senza saper, senza costume,
Dell'ozio amica, e che virtù non cura,

Predice l'avvenir e la ventura
A popol stolto che non vede lume

N° 3

14.

14. Joseph Wagner
Switzerland, 1706–1780
The Fortune Teller, 1777
after *Il Ciarlatano* by Giovanni Domenico Tiepolo
(Italy, 1727–1804)
Etching and engraving
39.5 × 51 cm
Mr. and Mrs. Richard S. Braddock

The Swiss-born Joseph Wagner settled in Venice
in 1739 and established himself as a print seller
and engraver. *The Fortune Teller*, dated 1777,
reproduces a painting by Domenico Tiepolo,
Il Ciarlatano (*The Charlatan*), now in the Balboa
Collection in Madrid. The scene is also closely
related to one of Domenico's frescoes for the Villa
Valmarana, in a room painted with scenes of
Carnevale. Itinerant showmen such as the fortune
teller here often caught Domenico's eye, who then
created scenes of surprisingly mixed audiences dur-
ing Carnevale, here in a rather friezelike manner.

Verses such as the moralizing, almost satirical
one in *The Fortune Teller* can be found in numer-
ous Venetian engravings issued by Wagner's shop
(see, for example, Alessandro Longhi's *Puppet
Show*, cat. no. 8).

– J.C.S.

Tiepolo's Cast of Characters

15. Giovanni Battista Tiepolo
Italy, 1696–1770
Study of a Bearded Man in Exotic Costume, 1750s
Pen and wash in brown ink on ivory laid paper
21.5 × 11 cm
Stanford University Museum of Art, Gift of
Mortimer C. Leventritt Fund, 1941.276

PROVENANCE: Marquis de Biron; Mortimer C.
Leventritt, San Francisco

LITERATURE: Stanford 1941, no. 276; Stanford
1973; Stanford 1982; Stanford 1993, p. 144,
no. 277

This drawing is representative of the kind of fig-
ure studies assembled in an album known as the
Sole figure vestite (Single dressed figures) now at
the Victoria and Albert Museum. Although this
drawing is not actually from the Victoria and
Albert album, it is believed to be from a similar
album of drawings that was subsequently sold and
disassembled. Reminiscent of the exotic magicians
and philosophers who appear repeatedly in
Tiepolo's etching series the *Scherzi di fantasia*, this
drawing exemplifies Giambattista's continued in-
terest in creating figures who express a sense of
theatrical gesture. As in this image, the figure
studies display a variety of active poses and bodily
postures and are viewed from different angles, re-
laying a sense of inventive freedom in the work.
Here the swift but nervous line work and ink
wash create a chiaroscuro effect, allowing for a
brilliant luminosity to shine on the figure, whose
eyes are half closed against the dazzling light.

As is the case with other images in the album,
this figure does not seem to have been borrowed
for use in any of Giambattista's paintings. As
drawn studies, the purpose of such ink sketches
remains unclear. The sheets show consistency in
overall execution, and, as George Knox suggests,
they may have been intended as a series of prints
for commercial publication, much like Watteau's
Figures de différents caractères (Figures of various
characters) and Domenico Tiepolo's *Raccolta di
teste* (Collection of heads).
— L.L. & D.Z.

15.

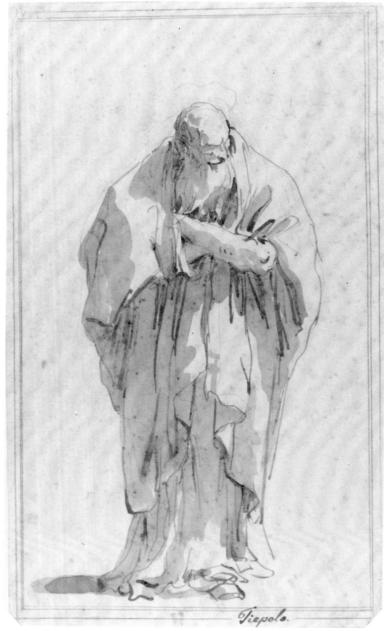

16.

16. Giovanni Battista Tiepolo *see p. 6*
Italy, 1696–1770
Old Man Standing with Arms Folded
Pen and brown ink and brown wash over
black chalk
21.9 × 13 cm
Museum of Fine Arts, Boston, Bequest of
Mrs. Edward Jackson Holmes, 1964

LITERATURE: Victoria and Albert 1975,
pp. 65ff.; Boston 1983, p. 66, no. 70

A leaf from the series of *sole figure vestite* (single
costumed figures), this drawing was not a study
for a future work but instead explored the ele-
ments and processes of constructing a figure. The
completeness of this drawing lends the old man a
certain self-sufficiency and individuality, con-
firmed by his refusal to return our gaze. As he
does in numerous drawings, Tiepolo betrays his
preoccupation with the issues of age and pictorial
identity. The viewer is shown only the man's long
beard and sloped shoulders, which function as im-
mediate indicators of advanced years. But with
Tiepolo's deft placement of line and wash, these
clues are enough. For despite the consuming, volu-
minous robe and partially illegible facial expres-
sion, Tiepolo skillfully foreshortens the tilted
head, suggesting a back slightly hunched with
age, and unerringly executes a wash and two lines
that schematically yet convincingly render a
sunken cheekbone and furrowed brow. Tiepolo
experiments with ways of representing pictorial
identity without providing a detailed description
of the figure's face; like a mask wearer, this fig-
ure's identity is expressed through gesture and
costume.

– J.H.

17. Giovanni Battista Tiepolo

Italy, 1696–1770

Chalchas, ca. 1757

Pen and ink and brown wash

19.5 × 13 cm

The Baltimore Museum of Art: Blanche Adler
Memorial Fund, and Gift of Marie Conrad Lehr,
by exchange, BMA 1965.36

PROVENANCE: Victor Bloch; sale, Sotheby's,
London, 19 November 1963, lot 97

LITERATURE: Cambridge 1970, no. 71

Tiepolo created 240 drawings of single, standing,
draped male figures, frequently bearded. This
large body of work has been categorized as *sole
figure vestite*. An album of eighty-nine such draw-
ings still exists in the Victoria and Albert Museum,
while most of the others have been disassembled
and dispersed. This exhibition includes five such
studies. While most are thought to be drawings
Tiepolo made for their own sake and are unrelated
to his painted oeuvre, *Chalchas* is apparently
related to the figure of the high priest in the Villa
Valamarana fresco, the *Sacrifice of Iphigenia*.

Although it is generally difficult if not impossi-
ble to establish a direct link between these draw-
ings and Tiepolo's paintings, a connection can be
made between the studies and Tiepolo's print se-
ries the *Vari Capricci* and the *Scherzi di fantasia*.
In both series, Tiepolo frequently features a
magician-philosopher type with a long beard and
robe, closely resembling such *sole figure vestite* as
Chalchas. This sage figure was a stock character
for Tiepolo, evidently one of his favorite actors.
In each study of this standing, bearded man
in a robe, Tiepolo represents him in a slightly
altered role.
 – D. Z.

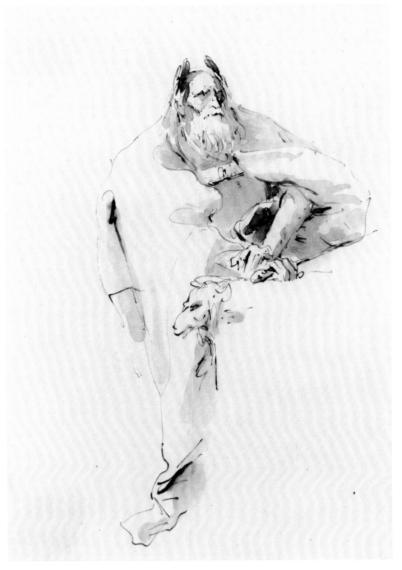

17.

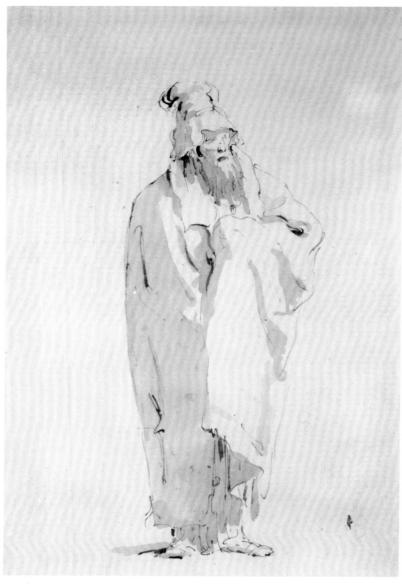

18.

18. Giovanni Battista Tiepolo
Italy, 1696–1770
Bearded Man Wearing a Cloak, ca. 1750
Pen and brown ink wash
20.6 × 13.7 cm
Santa Barbara Museum of Art, Gift of Wright S.
Ludington, 1964.12

PROVENANCE: Count Algarotti Corniani degli
Algarotti, Venice (1852)?; Edward Cheney,
Shropshire (1885)?; Christie's, London, 1914;
E. Parsons and Sons, London (?); Charles E.
Slatkin Galleries, New York: Wright S.
Ludington

LITERATURE: Santa Barbara 1964, no. 78; Iowa
City 1964, no. 77; Berkeley 1968, no. 58; Pomona
1976, no. 55; Santa Barbara 1976, p. 222

Standing, bearded men dressed in robes were a
favorite subject of Tiepolo's and featured in hun-
dreds of studies. Although this drawing may not
actually have been part of the album entitled *Sole
figure vestite* at the Victoria and Albert Museum,
it was most likely part of a similar group of such
studies that was subsequently sold and disassem-
bled. Many images in Tiepolo's two series of etch-
ings, the *Scherzi di fantasia* and the *Vari Capricci*,
contain bearded, robed magician and philosopher
figures that may relate (however indirectly) to
studies such as the *Bearded Man Wearing a Cloak*.

 The theme of masking comes into play in this
work on several levels. First, the large and baggy
cloak and hat serve literally to cover and hide the
body. The figure's pose and gesture—folded arms
and shut eyes—provide yet another barrier. His
face, though exposed, still appears masked, not
only because most of his forehead is covered by
the hat and his cheeks by his beard, but also by
the way Tiepolo uses the wash around the outer
part of the face to contrast the masklike white that
remains at the center. His use of the wash for the
figure's mouth and nostrils also contributes to the
masklike effect.

 – D.Z.

19a. Giovanni Domenico Tiepolo
Italy, 1727–1804
Two Old Men
after G. B. Tiepolo (Italy, 1696–1770)
Etching
27.9 × 8.8 cm
Fine Arts Museums of San Francisco,
Achenbach Foundation for Graphic Arts,
1963.30.301

19b. Giovanni Domenico Tiepolo
(Italy, 1727–1804)
A Man Seated and a Woman Carrying a Vase
after G. B. Tiepolo (Italy, 1696–1770)
Etching
28 × 9.2 cm
Fine Arts of Museums of San Francisco,
Achenbach Foundation for Graphic Arts,
1963.30.301

LITERATURE: De Vesme 110, 111;
Rizzi 128, 129

Printed on the same piece of paper, this pair of
etched scenes experiments with the possibilities of
portraying space in a narrow, vertical frame. Walk-
ing side-by-side, the two exotically dressed old
men emphasize the vertical height of the frame.
The scene on the right, in contrast, with the
seated man staring over his shoulder at the vase-
bearing woman, child in tow, breaks up the verti-
cal space. It deploys opposing diagonals stacked
vertically to indicate recession into space and picto-
rial depth. Inscribed at the bottom corners of each
image *Io: Bapt. Tiepolo inv:*, in the lower left, and
Io: Dom: Filius sculp:, in the lower right, the two
works were conceived of as independent images.

Domenico created a niche for himself as an
etcher and printmaker even though he actually
produced few original etchings: instead, most
were at least based on designs by his father. In
translating the drawn and painted designs into a
series of printed and etched lines, Domenico in-
tended to circulate the products of Giambattista's
invenzione on a wider scale. The choice of subject
matter bespeaks father and son's fascination with
scenes of everyday life and how they find expres-
sion on paper, while incorporating features—the
old men in Eastern costume who must be seen
as sages—that become stock characteristics in
Giambattista's noncommissioned work. This
hybrid of real life and invention can be found in
many other eighteenth-century European masters,
from Goya to Blake.

– Y.Y.

19a.

19b.

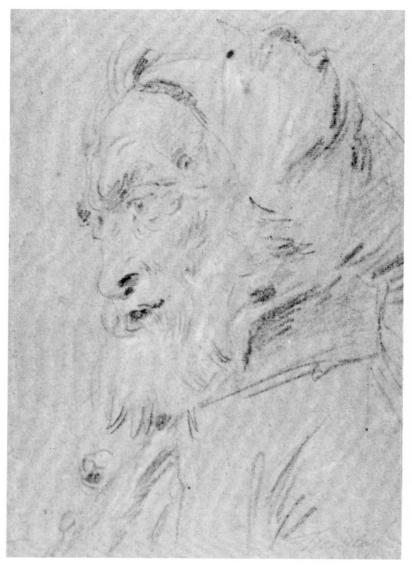

20.

20. Giovanni Domenico Tiepolo
Italy, 1727–1804
Head of an Old Man
Black and white chalk on gray-blue paper
24.8 × 17.6 cm
University Art Museum, University of California,
Santa Barbara, Gift of the Lorser Feitelson and
Helen Lundeberg Feitelson Arts Foundation,
1985.164

This head has never been convincingly related to
any of the frescoes, oil paintings, or etchings of
Giambattista or Domenico Tiepolo. However, as
a representative of the sage type, with his wizened
features and long beard, it is similar to a number
of drawings by father or son in European collec-
tions, as well as to several painted works. As such,
it can be related in subject matter to a number of
Giambattista's drawings and etchings in the pres-
ent exhibition (see, for example, the drawings
included here as catalogue numbers 16 and 17
and the etching from the *Scherzi di fantasia*
[cat. no. 58]).

The drawing's attribution has been the subject
of scholarly debate, in part due to substantial diffi-
culties in distinguishing between father and son
when discussing the chalk drawings. Both made
study drawings for their frescoes and oil paint-
ings, and both often used black chalk on bluish
papers. The question is further complicated by
Domenico's practice of copying his father's work,
as in his etching *Two Old Men* (cat. no. 19a).
George Knox has attributed the drawing to the
early years of Domenico's career, when he was
fully integrated in his father's studio.
— J.C.S.

21. Francesco Salvator Fontebasso

Italy, 1707–1769

Two Turbaned Men and a Seated Woman and Child

Pen and brown ink, brush with brown and gray wash, over black chalk; vertical ruled stylus lines at left and right

37.5 × 26.2 cm

The Metropolitan Museum of Art, Rogers Fund, 1961. (61.56.2)

PROVENANCE: Henry Scipio Reitlinger (Lugt S. 2274a)

LITERATURE: Princeton 1966, under no. 98; Metropolitan 1971, p. 77, under no. 181

In this drawing, Fontebasso's subject matter is close to that of many drawings by Giambattista Tiepolo—the representation of exotic figures whose identity is constructed through an emphasis on theatrical costume and gesture. The two men in Fontebasso's drawing don voluminous and explicitly detailed costumes, so dominant that they come to define the body itself. The bearded man on the left, especially, is reminiscent of the sage figure so prevalent in Giambattista's work and may in fact derive from it. Given Venice's unique position during the eighteenth century as a point of dynamic intersection between Eastern and Western cultures, one can sense Fontebasso's relish in the exotic: the miterlike headgear, the sumptuous robe of the bearded man and the oriental costume of the other, as well as the distinctions in age and authority mapped in each man's gesture, posture, and facial expression. For all the work's resemblance to themes found in Giambattista's work, Fontebasso's weighty tone and emphatic description are most likely the artist's response to the call for historical accuracy and pictorial seriousness made by sensitive critics of the 1760s, who opposed fictive and flighty works (with which both Giambattista and Domenico Tiepolo were associated) as signs of Venetian decadence.

– J.H.

21.

22.

22. Giovanni Battista Tiepolo
Italy, 1696–1770
Walking Man, before 1762
Pen and brown ink with brown wash over
black chalk
19.1 × 12.7 cm
Ackland Art Museum, The University of North
Carolina at Chapel Hill, Ackland Fund, 71.32.1

PROVENANCE: Count of St. Saphorin;
Paul Drey Gallery

LITERATURE: *Art Journal* 1971–72; Seattle 1974,
no. 16, repro. p. 24 and on cover

In many of his drawings of single figures, Tiepolo
curiously depicts them from behind. In so doing,
he relies on two visual elements commonly used
in Italian theater to express character when a face
is not depicted—costume and gesture. The ano-
nymity of the figure in this drawing constitutes a
discreet form of masking. By drawing only the
back and right side of *Walking Man*, Tiepolo de-
nies the viewer any identity that might be attrib-
uted to the figure. Tiepolo masks this figure not
only by depicting him from the back but also
through an emphasis on the figure's unusual cos-
tume, which hides most of the body. Similar to
the ways in which the masked actors of the *comme-
dia dell'arte* relied on exaggerated gesture and
pose to attract an audience's attention, Tiepolo
also emphasizes gesture by accentuating the fig-
ure's strangely positioned foot as well as his right
hand (which may well be gloved) with its exagger-
ated thumb.

Like catalogue numbers 23 and 24, this draw-
ing may well have belonged to a collection of
studies intended for Tiepolo's workshop.

–D.Z.

23. Giovanni Battista Tiepolo
Italy, 1696–1770
*Standing Man in a Cap and Cape, His Left Arm
Partly Raised*
Pen, brown ink and gray brown wash
21 × 13.9 cm
The Art Museum, Princeton University, Bequest
of Dan Fellows Platt

PROVENANCE: Count Algarotti; Cheney (?);
Dan Fellows Platt, bought at Parsons in 1925

LITERATURE: Knox 1964, no. 16; Princeton
1977, no. 622

This drawing of a standing man was most likely
intended for a collection of similarly finished
pieces to be used in Giambattista's workshop.
These single figures constitute a visual repertoire
for the workshop, the *dramatis personae* who can
be called on later to be included in larger composi-
tions. Viewing the figure as an actor, we find that
he too wears a mask akin to those worn in the
Venetian Carnevale. The actual identity of the
character is irrelevant, for he embodies the essential
nature of a type. Draped in an adaptation of Near
Eastern garb, this enigmatic figure evokes the
imagery of Old Testament prophets, patriarchs,
and seers. Given Venice's position during the eigh-
teenth century as an intersection between Eastern
and Western culture, one can see how the taste for
an imagined Orient might emerge. His extended
left arm and troubled look give this figure a dra-
matic, expressive intensity and psychological
depth typical of many of Giambattista's render-
ings of character types.
 – C.U.

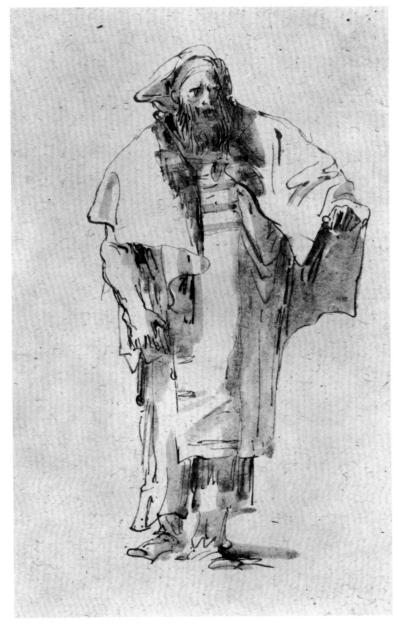

23.

24.

24. Giovanni Battista Tiepolo
Italy, 1696–1770
Standing Woman Facing Left in a Hood and Cape
Pen, brown ink and brown wash
19.1 × 9.2 cm
The Art Museum, Princeton University, Bequest
of Dan Fellows Platt

PROVENANCE: Dan Fellows Platt, bought at
Holoway in 1925

LITERATURE: Knox 1964, no. 15; Princeton
1977, no. 620

Giambattista's interest in costume and dramatic
gesture is apparent in this depiction of a woman
that was probably intended for use in his work-
shop. The practice of collecting such finished
drawings for use in future compositions, and
as models for junior members of a workshop,
extends back in the Venetian tradition at least
to Jacopo Bellini, in the fifteenth century.

Giambattista's attention here was focused not
on representing the details of anatomy but on ex-
ploring the manner in which drapery reveals the
contrapposto of the body beneath it. The costume
of the woman is particularly intriguing. Her dress
combines the restrained forms of classical drapery
in her girded garment under an open cape, exag-
gerated collar, and crumpled hat; these mysterious
upper garments are suggestive of nothing so much
as the disheveled and cast-off costume of one of
the Zannis from the *commedia dell'arte*. Like her
clothes, the woman's face is also enigmatic, her fea-
tures not so much represented as insinuated. Her
face is masked by shadows created by the wash,
making her mood difficult to read. In many of
these figure studies, Tiepolo deprives his subject
of an identity.

– C.U.

Caricature

25. Giovanni Battista Tiepolo (?)
Italy, 1696–1770
Caricature: An Elderly Couple
Pen and brown ink, brush and pale brown wash,
over black chalk
20.9 × 15.6 cm
The Metropolitan Museum of Art, Rogers Fund,
1937. (37.165.8)

PROVENANCE: Marquis de Biron; purchased in
Geneva in 1937

LITERATURE: Benesch 1947, no. 39; Byam Shaw
1962, p. 57 note 2; Pignatti 1970, p. 85, pl. XXIX,
in color; Byam Shaw 1970, p. 239 note 11, as
possibly by Lorenzo Tiepolo; Pignatti 1974,
pl. LVI, in color; Victoria and Albert 1975, p. 98,
under no. 311

25.

As a mixture of fact and fancy, formalism and
spontaneity, caricature was a genre well suited to
Tiepolo's attentive eye and subject interests. Cari-
cature can be seen to constitute a form of masking
insofar as it serves as a visual device altering iden-
tity while at the same time exchanging conceal-
ment for the display of an exaggerated and often
grotesque persona. The swift, unerring line and
delicate washes in this caricature depict an elderly
couple. Beholding each other as if for the first
time, their penetrating and searching eyes meet
with a severe intensity, as if attempting to bore
through the mask of the other.

But what happens when the raw, "unmasking"
quality of caricature addresses those who are
masked? As it both hides and displays an identity,
the mask places an ever-shifting distance between
viewer and the masked, as well as among the
masked themselves. The couple's mutual scrutiny,
replicated in the artist's looking and in our own,
challenges us to look more closely beneath the illu-
sory surface. It was a timely challenge, as Venice's
waning power and authority during the eigh-
teenth century found glory in the facade of cere-
mony and celebration it maintained for its visi-
tors. Beyond a parody of social mores and of
contemporary society, Tiepolo's true subject in
this witty caricature concerns the act, and the art,
of looking.
 – J.H.

26.

26. Giovanni Domenico Tiepolo
Italy, 1727–1804
Caricature of a Man in Left Profile, Tricorn in Right Hand, Sword at Side
Pen, gray ink and gray wash
17.7 × 10.3 cm
The Art Museum, Princeton University, Bequest of Dan Fellows Platt

PROVENANCE: Dan Fellows Platt, bought at Asta, Venice, in 1928

LITERATURE: Knox 1964, no. 70; Princeton 1977, no. 657

The genre of caricature can be viewed as the graphic embodiment of the spirit of Carnevale. Traditionally, Carnevale is a time when society is turned on its head and the faults and idiosyncrasies of individuals and entire classes are exaggerated for comic effect. Like the pre-Lenten plays of Carnevale, in which hierarchy was inverted and one's superiors were chided for their shortcomings, caricature is an art of equality that cuts across class lines and mocks the high as well as the low. The festivities of Carnevale were not merely gratuitous revelries for tourist and Venetian alike; they also served as a recognized safety valve that helped society regulate itself by releasing pressures accumulated throughout the year that might otherwise have led to social unrest. Domenico's caricatures exhibit a gently mocking tone without venturing into the realm of the grotesque or the vulgar. He accentuates the foibles of his subjects, bringing them into sharp and amusing focus. Here we see a member of the aristocracy, his chest puffed with pride beneath his coat, his kerchief issuing forth from his neck like exotic plumage. The tight-lipped and drawn face, with aquiline nose and beady eyes, stares straight ahead, oblivious to the viewer. His aspect is that of a large bird, preening and strutting in earnest solemnity.

– C.U.

27. Giovanni Domenico Tiepolo
Italy, 1727–1804
Caricature of a Man in a Cap, Facing Left
Pen, brown ink and brown wash
17.5 × 9.2 cm
The Art Museum, Princeton University, Bequest
of Dan Fellows Platt

PROVENANCE: Dan Fellows Platt

LITERATURE: Knox 1964, no. 65; Princeton
1977, no. 653

Originally attributed to Giambattista Tiepolo,
this drawing from a series of caricatures has been
tentatively reassigned to his son Domenico. Like
so many of Domenico's caricatures, the drawing
evokes the flavor of the *commedia dell'arte* through
the buffoonish attire and distorted visage of the
figure. The clowning characters from the Italian
comedy, especially the droll figure of Punchinello,
make numerous and often unexpected appear-
ances throughout the drawings of both Tiepolos.
Here the long, loose smock—so suggestive of the
costume of Punchinello—accentuates the slight
proportions of the figure, whose bulbous head is
precariously perched atop too small a frame. The
head itself is the object of particular fascination;
the impossibly large nose and sloping forehead
mimic the form of the man's cap, creating a curi-
ous mirroring effect between the two. – C.U.

27.

28.

28. Giovanni Battista Tiepolo

Italy, 1696–1770
Caricature of a Man with Cloak and Wig, Seen from Behind, ca. 1754–57
Black chalk and pen and wash in brown ink on ivory laid paper
20.2 × 10.1 cm
Stanford University Museum of Art, Committee for Art Acquisitions Fund, 1974.200.1

PROVENANCE: Family collection, counts of Valmarana, Vicenza (?); Count Sachetto (?); Count Paul Wallraf, London; sale, Christie's, London, 25–26 June 1974, lot 53

LITERATURE: Morassi 1959, nos. 76–87; *Connoisseur* 1959; van Schaak 1962, p. 84, no. 53; Stanford 1981; Stanford 1982; Stanford 1993, p. 144, no. 276

Giambattista created numerous caricature drawings that were innocently satirical in tone. Indeed, three albums of caricatures, all of which were subsequently dismantled, come from Giambattista's studio. The image here belongs to a series of twelve caricatures thought to have come from these albums and published in 1962 by Eric van Schaak. Tiepolo took the subjects for these drawings from the various social strata of Venetian life and simplified each image into an amusing artistic interpretation. Here, Tiepolo playfully elongates the figure of a wigged nobleman, such as those represented in catalogue numbers 7–10. Seen only from behind, his identity is irrelevant. Despite his anonymity, his social status is nevertheless made obvious through his periwig and robe, remnants of French fashion brought to Venice in the late seventeenth century. His sticklike legs suggest the frailty of the figure beneath the trappings of his office. Tiepolo masks this figure's identity not only by depicting him from the back but through the device of caricature which, in this case, equates the figure with his periwig, the wig being a cover-up that disguises complexity of personality.

—L.A.L. & D.Z.

29. Giovanni Battista Tiepolo
Italy, 1696–1770
A Monk, ca. 1757
Pen and brown ink and gray wash on laid paper
17.8 × 12 cm
Fine Arts Museums of San Francisco, Achenbach
Foundation for Graphic Arts, 1976.2.25

PROVENANCE: From the album *Tomo terzo de caricature*; Algarotti-Corniani (?); Breadalbane (?); Langton House, Duns, Berwickshire; sale, Edinburgh, Dowells, 25 March 1925, lot 1004, bought by John Grant, bookseller, Edinburgh; Arthur Kay; Colnaghi, London (early 1940s); Peter Granger van der Poel; Mrs. Susan Welling

This drawing of a figure seen from the rear, wearing a ridiculously large straw hat, is typical of Giambattista's mature wash drawings, where the wash is applied in two discrete values, one medium and one dark. Over an underdrawing Giambattista drew a pen contour that was then accented at points with a fully loaded brush and finally amplified and unified with a more expansive wash of medium value.

The figure can be identified as a monk by the hooded cloak, gathered at the waist, and the walking stick. The exaggeration of the hat adds a whimsical touch and is testimony to Tiepolo's capacity for caricature that manifested itself exclusively in his drawings. The rapidly executed lines and loose passages of diluted ink describe the external, clothed appearance of the figure, however, rather than the individual details of his face.

What might seem to be an overemphasis on clothing in Tiepolo's work gains currency in light of eighteenth-century Venetian social history. Venice, once a great mercantile power of Europe, found its economic and political wealth increasingly threatened in the wake of Napoleon's rise. Yet its position as one of the great cosmopolitan centers forced Venice to keep up appearances— at least the appearance of cultural wealth, as signified in the details or trappings of costume.

– Y.Y.

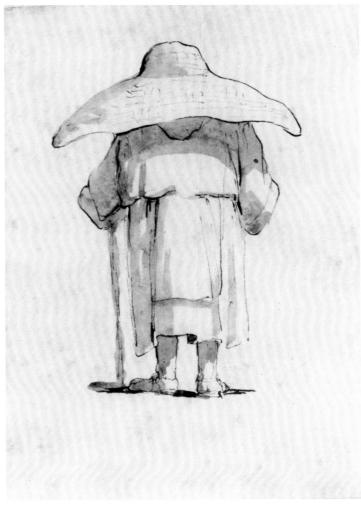

29.

The Commedia dell'Arte, Theatricality, and Punchinello

30 and 31. Jacques Callot
France, 1592–1635
Les Balli di Sfessania, 1–6 and 7–12,
after 1621
Etching
each approximately 7.6×9.5 cm
Honig Family Collection

PROVENANCE: R. E. Lewis, Inc.

The *Balli di Sfessania* is a series of twenty-four small etchings of which twelve plates are exhibited here. The subject matter relates to a particular form of improvisational street theater known as the *commedia dell'arte*, which regained popularity in the eighteenth century. The *commedia dell'arte*, a term not actually coined until the eighteenth century, refers to a theatrical tradition that arose in Italy during the second half of the sixteenth century and whose three essential characteristics were plot structure, improvisation, and mask. The *commedia dell'arte* incorporated both formalism and spontaneity: on the one hand, a character's personality, costume, mask, and gesture were strictly defined and carried over from play to play; on the other hand, scripted dialogues were not used, allowing the troupe of players to improvise within a consistent plot structure. The actors wore masks to clarify their role to an audience familiar with the physical traits and personality traits of each character. In the case of theatrical masks, then, role-play was defined by the mask worn. Offstage, however, in the context of Venetian social life, masks were devices that liberated one from the role he or she might otherwise be expected to play.

Callot's delightful images help bring the characters of the Italian *commedia dell'arte* to mind. These popular prints have been valued both as documents of theatrical history, appearing in nearly every illustrated study of the *commedia dell'arte*, and as evidence of the artist's personal fantasy. In fact, these etchings occupy a space somewhere between fantasy and reality insofar as they were Callot's imaginative response to the real stimuli he encountered during his Italian period (1608–21).

The frontispiece of the *Balli* reproduced here is the only one of the series that represents a stage and that contains more than two characters. Otherwise, each of the etchings involves a pair of comedic actors (frequently masked) in an undefined outdoor space. The names of these characters, whose trademark personalities were familiar to *commedia dell'arte* fans, are printed beneath the figures. The Punchinello character in one of the etchings reproduced here helps to provide a visual history of the representation of this character, which the Tiepolos took up in the century following Callot's *Balli*.

– D.Z.

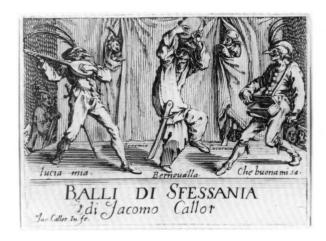

BALLI DI SFESSANIA
di Jacomo Callot

lucia mia. Bernoualla. Che buona mi sa.

Cucorongna. Pernoualla.

Cap.ᵃ Cerimonia. Sig.ᵃ Lauinia.

Smaraolo cornuto. Ratsa di Boio.

Cicho Sgarra. Collo Francisco.

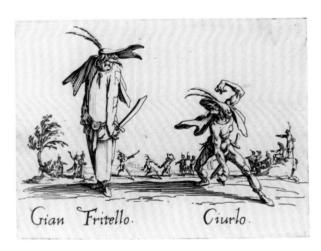

Gian Fritello. Ciurlo.

30.

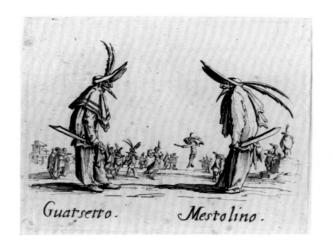

Guatsetto. Mestolino.

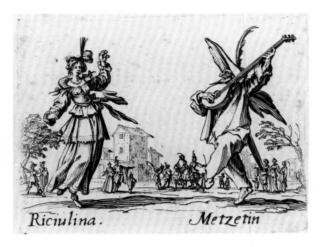

Riciulina. Metzetin

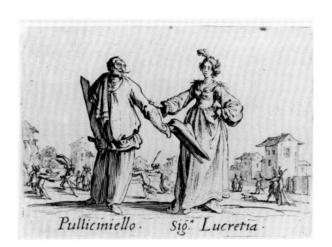

Pulliciniello. Sigᵃ Lucretia.

Cap. Spessa Monti. BaGattino.

Scaramucia. Fricasso.

Scapino. Cap. Zerbino

31.

32. Giovanni Battista Tiepolo
Italy, 1696–1770
Pulcinella
Pen and ink and ink wash
12.7 × 7.6 cm
Grunwald Center for the Graphic Arts, UCLA,
Rudolf L. Baumfeld Bequest, 1988.9.301

PROVENANCE: Orrel P. Reed, Jr., Los Angeles;
Rudolf L. Baumfeld, 1988

This briskly executed pen-and-ink-wash drawing describes the Punchinello figure found in the traditional Italian *commedia dell'arte*, a character revived by Renaissance writers yet whose ancestry can be loosely traced to early Roman comedy. In fact, the roots of the *commedia dell'arte* are thought to go back to ancient Greek and Roman comedy. The Neapolitan actor Silvio Fiorillo delivered the first stage portrayal of Punchinello in 1628.

Punchinello's physical attributes are a clue to his nature: his hunched back identifies him as a country laborer, and his large belly is a sign of his gluttony, laziness, and love of gnocchi, as can be seen in catalogue number 33. His traditional costume consists of trousers and a belted, blousy shirt with a ruffled collar topped by a tall sugar-loaf hat, all in white. The final piece of the ensemble is a black half-mask sporting a long crooked nose that identifies him with his namesake, *pulcinella*, meaning "young turkey or chicken." This costume became popular during Carnevale; the Punchinello character itself triumphed within the roving *commedia dell'arte*. Here players continually reinvented the role of Punchinello in a comic improvisation, performed in the streets for the Venetian public. The character's licentious and lecherous behavior prompted authorities in 1760 to consider banishing these buffoons in white from the Piazza di San Marco, as they were thought to be offensive to Venetian noblewomen. But the period of Carnevale and the Dionysian behavior it induced can be seen as a necessary social outlet that compensated for the otherwise rigid social mores imposed by the Catholic Church.

Along with other Venetian artists, Giambattista found in this theatrical character a figure ripe for pictorial representation. The artist created at least eighteen Punchinello drawings, and the character is also in a few etchings of the 1740s.
– L.A.L. & D.Z.

32.

33. Georg Friedrich Schmidt
Germany, b. 1712
Three Punchinelli Cooking Gnocchi, 1751
after Giovannia Battista Tiepolo
(Italy, 1696–1770)
Etching
21.9 × 23.5 cm
Harry and Frances Whittelsey, Huntington Bay,
New York

PROVENANCE: Collection Rev. J. Burleigh James
(Lugt 1425); David Tunick, New York

LITERATURE: Santifaller 1976, pp. 204–9; Knox
1984, p. 444, no. 19

In contrast to his son Domenico's portrayal of a younger and leaner Punchinello, Giambattista's Punchinello embodies the grotesque, a common feature of Carnevale. In *Three Punchinelli Cooking Gnocchi*, the three stout, hunchbacked figures wear the trademark sugar-loaf hat and beaklike mask. Huddled around a pot of gnocchi, the central figure cooks with one hand and consoles with the other. Bent over, with their heads hung low, they seem to be a gloomy lot. Perhaps the gnocchi, small dumplings made of semolina pasta or potato, will lift their spirits. Punchinello's insatiable

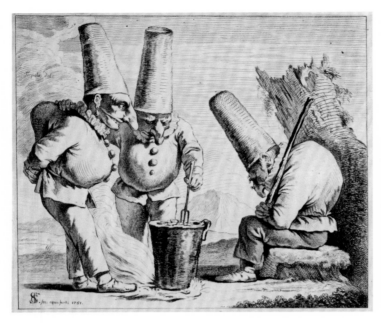

33.

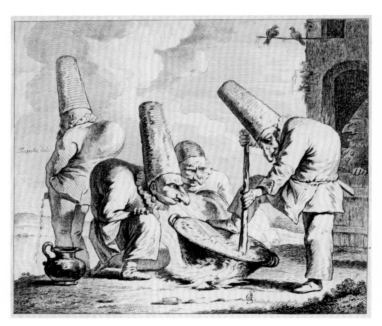

34.

34. Georg Friedrich Schmidt

Germany, b. 1712
Four Punchinelli Cooking Polenta, 1751
after Giovanni Battista Tiepolo (Italy, 1696–1770)
Etching
21.9 × 23.5 cm
Harry and Frances Whittelsey, Huntington Bay, New York

PROVENANCE: Collection Rev. J. Burleigh James (Lugt 1425); David Tunick, New York

LITERATURE: Santifaller 1976, pp. 204–9; Knox 1984, p. 443, no. 17; Gealt 1985, p. 64 ff.I, no. 20

In this, the second of a pair of etchings Schmidt created after drawings by Tiepolo, four Punchinelli gather around a pot of polenta. The figure on the right uses his foot to support the pot at an angle while fervently stirring the polenta with the traditional long wooden stick. On the left, another Punchinello assists him as a human bellows. The figure in the center curiously does not wear the traditional sugar-loaf hat. The standing Punchinello, with his back to us, relieves himself.

The misshapen figures, with their grotesquely hunched backs and beaked noses, convey an image of brotherhood. Yet the Punchinello pissing, at the far left, undermines such a sympathetic reading and reminds us again of the travesties they are allowed as embodiments of the carnivalesque. The depiction of pissing and eating (taking into account that the Punchinelli will be consuming the polenta) relate to the glorification of the lower bodily region, appropriate to a "world turned upside down." In opposition to official culture, Carnevale served as a medium through which norms were inverted and otherwise transgressive behavior permitted. The wearing of masks and costumes liberated Venetians from social constraints and turned the city into a temporary stage.

– Y.Y.

appetite for gnocchi expressed the comic gluttony and excess that typified Carnevale.

Images like this one featuring the gnocchi motif are believed to refer to a festival in Verona known as the *venerdi gnoccolare*, which was the last Friday of Carnevale. Peasants made their way to the Palazzo del Podestà, where the mayor would be offered a dish of gnocchi and a glass of wine in the Piazza San Zeno.

– Y.Y. & D.Z.

35. Studio of Giovanni Domenico Tiepolo

Italy, 1727–1804
The Minuet, mid to late eighteenth century
Oil on canvas
78.1 × 108.6 cm
New Orleans Museum of Art; Samuel H. Kress Collection, 61.88

PROVENANCE: Col. Robert Adeane, Babraham Hall, Cambridge; Christie's, London, 13 May 1939, lot 45, as "The Masked Ball" by Giovanni Battista Tiepolo; David M. Koetser, New York, 1952; Samuel H. Kress, 1953; given to New Orleans Museum, 1961

LITERATURE: Louisville 1990, p. 52, no. 37

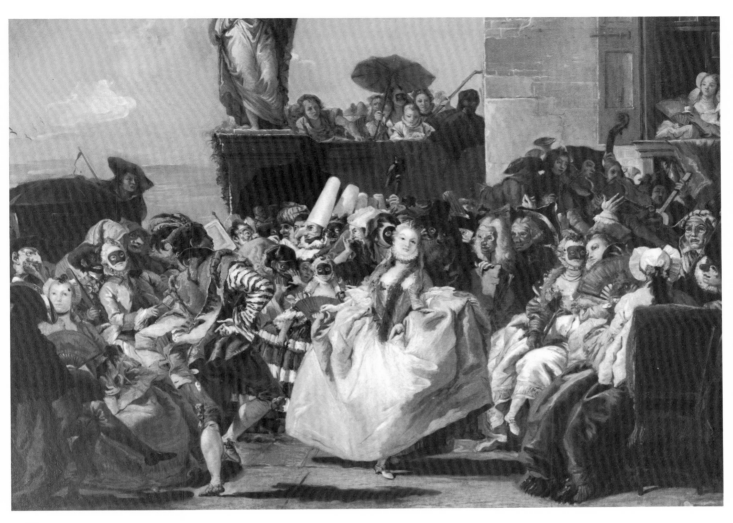

35.

Based on an oil painting by Domenico Tiepolo of about 1750 now in the Louvre, *The Minuet* is one of several versions of the subject considered to be copies from Domenico's studio. The quality of its execution and its fidelity to the original suggest that it probably was produced shortly after the Louvre canvas. In addition to representing the *commedia dell'arte* character Punchinello in his series *Divertimento per li regazzi* (Amusement for the young), Domenico painted several canvases such as this one and a series of frescoes that depict Carnevale scenes and include other *commedia dell'arte* characters.

In this engaging scene of Carnevale, the composition focuses on the richly dressed figure of a dancing woman. Unmasked among the throng of pleasure seekers, the young woman flirtatiously meets the viewer's eye. Her undisguised appearance and confrontational gaze raise questions regarding her status; it is likely that she is one of the legions of courtesans for whom Venice was

famous in the eighteenth century (she could also be one of the Lovers, the only characters from the Italian comedy troupe who did not wear a mask). Surrounding her are figures wearing the masks of the *commedia dell'arte*: the distinctive visages of two Punchinelli, with their conical hats and beaked noses, can be found to the left of the central figure, while a figure dressed as Mezzetin (another *commedia dell'arte* character recognizable by his striped sleeves) dances in the left foreground. The lecherous patriarch, Pantaloon, holding a book, can be seen leering to the right of the dancer. Pantaloon was a retired merchant whose stinginess, simple-mindedness, and bungled love affairs eternally cast him as the dupe. A mysterious hand appears directly in front of Pantaloon, attempting to lift the dancer's skirt.

– C.U.

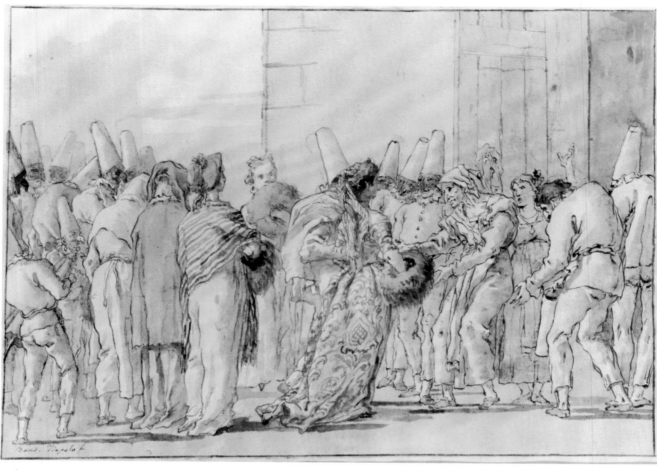

36.

36. Giovanni Domenico Tiepolo

Italy, 1727–1804
Punchinello's Father Brings Home His Bride
Black chalk, pen and brown ink, and brown wash
29.5 × 40 cm
Peter Jay Sharp Collection, courtesy National
Academy of Design, New York

PROVENANCE: Sale, Sotheby's, London, 6 July
1920, lot 41; Richard Owen, Paris; Paul Suzor,
Paris; sale, Hôtel Drouot, Paris, 8 December 1978,
lot 39; Wertheimer, Paris; Artemis

LITERATURE: Bloomington 1979, S 14, p. 143;
Knox 1983, 124–46, as no. 4 of the series; Gealt
1985, no. 12; National Academy 1994, p. 74

This image of Punchinello from Domenico's
series of 104 drawings entitled *Divertimento per
li regazzi* belongs to the first part of the series,
which revolves around the birth and marriage of
Punchinello's father. As number four in the series
(Domenico inscribed these numbers in ink in the
top left corner, though they are often covered by
the mount), this work is bracketed by *The Mar-
riage* and *The Marriage Feast*, neither of which
is exhibited here, although the *Venetian Banquet*

(cat. no. 39) from Boston's Museum of Fine Arts
lent its composition to *The Marriage Feast*. This
work has in the past been known by other titles,
such as *Punchinello Presents His Fiancée* and *The
Return to the House*, which serves to point out
that although Domenico assembled the series
of works, he did not give titles to each sheet.

The bride, in her brocade gown, immediately
draws the viewer's attention, yet her face remains
masked by the brown wash veiling her profile; her
face is obscured, as are the faces of almost all the
figures in the drawing. This creates the paradoxi-
cal effect of drawing the viewer into the scene
while simultaneously distancing him from the
center of the action.

– D.Z.

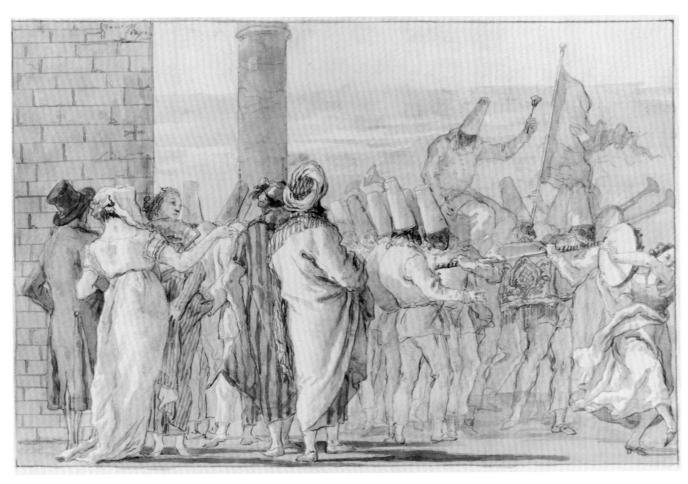

37.

37. Giovanni Domenico Tiepolo

Italy, 1727–1804
Bacchanale del Gnocco, also called *Punchinello Carried in Triumph in a Procession*, ca. 1800
Pen and brown ink and brown wash over chalk on cream laid paper
35.5 × 47.4 cm
The Detroit Institute of Arts, Founders Society Purchase, General Membership Fund, 55.487

PROVENANCE: Richard Owen, Paris; Countess Wachtmeister; sale, Sotheby's, London, 15 December 1954, lot 109; Marianne Feilchenfeldt, Zurich

LITERATURE: Newberry 1955–56; Birmingham 1958, no. 20; Bloomington 1979, pp. 25, 28, 158–59; Knox 1984

The figure of Punchinello has a particular resonance in the historical context of eighteenth-century Venice. The *Bacchanale del Gnocco* is a scene from Domenico's series *Divertimento per li regazzi* (Amusement for the young), which chronicles the tragicomic life of Punchinello. The narrative details Punchinello's exploits in which he masquerades in a variety of occupations and social

roles and ends with his death, after which only his hollow mask survives as testimony of his adventurous life. At the same time, the Republic of Venice experienced the loss of its independence in the wake of the Napoleonic invasions; the fate of Punchinello in the *Bacchanale del Gnocco* can be seen as mirroring the fleeting triumph of the Venetian Republic as a whole.

Like a piece of Venetian street theater, the public spectacle here entertains the viewer as we watch Punchinello carried in triumph, holding up a gnocco on a fork. Punchinello's love of gnocchi referred to the gluttony of Carnevale, the period of great indulgence preceding Lent. Faced with the backs of the spectators in the scene, we as viewers participate in the spectacle.

– J.H.

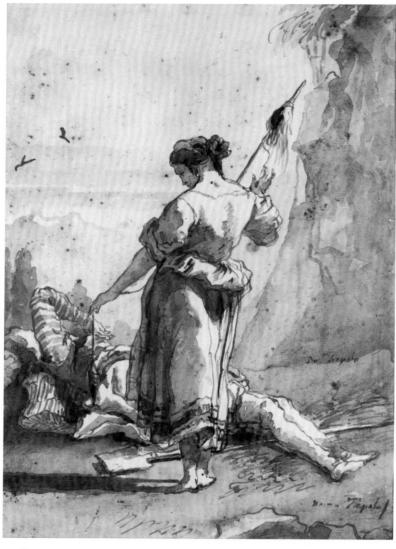

38.

38. Giovanni Domenico Tiepolo
Italy, 1727–1804
Woman with Distaff and Sleeping Figure, 1790s
Pen and wash in brown ink over black chalk
on ivory laid paper
26 × 18.2 cm
Stanford University Museum of Art,
Gift of Mortimer C. Leventritt, 1941.279

PROVENANCE: Kaye Dowland (Lugt 691);
Hill sale, Sotheby's, London, 27 June 1928;
bought by Tancred Borenius for £23;
Mortimer C. Leventritt, San Francisco

LITERATURE: Stanford 1993, p. 339

Domenico frequently borrowed from other artists
in his work, most commonly from his father,
Giambattista, in whose shadow he is often de-
scribed as living. Lorenz Eitner has suggested that
Domenico is here borrowing from two sources:
the standing female figure is taken from an etching
by Nicholaes Berchem of 1652, while the reclin-
ing figure derives from the shepherd in plate six
of Cornelis Bloemaert's *Pastorals*, which is in turn
derived from designs by Abraham Bloemaert.

The meaning of the drawing is difficult to de-
termine. The reclining figure has often been
thought to be a Punchinello, although this comic
figure's distinguishing mask is hard to locate in
the drawing. Eitner argues that this identification,
coupled with the spindle the young woman car-
ries, may suggest a theme of sloth confronting in-
dustry. While the subject remains unclear, its style
resembles Domenico's drawings done in the 1790s
after his return from Spain. These late works have
generally been placed in two categories, the *Diver-
timento per li regazzi* (or the Punchinello series)
and the *Scenes from Contemporary Life*, a series
into which this drawing, like catalogue number
39, can most likely be placed. Like Giambattista's
famous print series, these two categories of draw-
ings were not executed for patrons, who by then
sought works in the new classicizing style, but
were carried out for Domenico's own pleasure.

– L.A.L. & J.C.S.

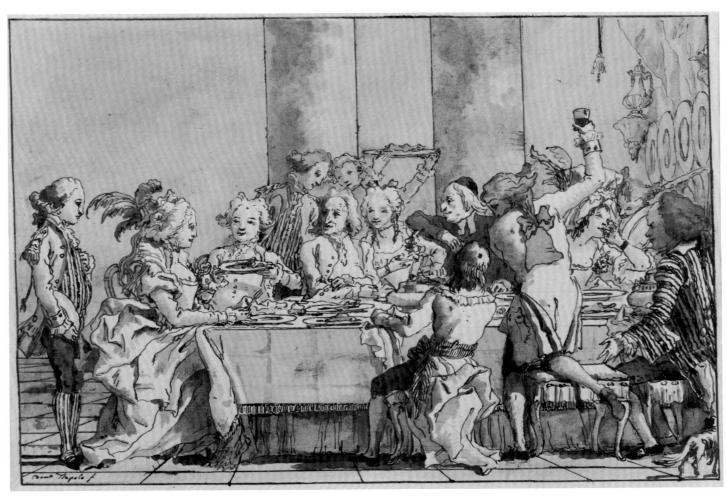

39.

39. Giovanni Domenico Tiepolo
Italy, 1727–1804
A Venetian Banquet, ca. 1791
Pen and brown ink and wash over black chalk
37.2 × 50.1 cm
Museum of Fine Arts, Boston, Arthur Tracy
Cabot Fund, 1966

PROVENANCE: Sale, Sotheby's, London,
11 November 1965, lot 19, repro.

LITERATURE: Boston 1983, p. 78, no. 89

In the twilight of his career, Domenico Tiepolo
completed two series especially relevant to this ex-
hibition. Both the *Divertimento per li regazzi* (the
Punchinello series) and the *Scenes of Contemporary
Life* take the *comédie humaine* as its subject, captur-
ing the follies, joys, and tragedies of contemporary
society with a wit and vitality rivaling the work of
Hogarth and Goya. This particular composition
actually appears in both series: first as this draw-
ing of a Venetian feast, then as the marriage feast
of Punchinello's parents. Tiepolo's social commen-
tary, however, is not scathing. There seems to be a
degree of complicity on the artist's part: the frivo-
lous and decadent nature of the banquet is re-
corded without harsh criticism or contempt. In-
stead, one can sense a certain delight in Tiepolo's
flirting yet detailed line and delicate washes. The
artist stands between two worlds, both outside as
an attentive observer and inside as a participant.

Domenico's simultaneously satirical and oddly
nostalgic treatment of this subject resonates with
its historical context. By the end of the eighteenth
century, the symptoms of Venice's declining
power and influence had become painfully ap-
parent. Drawing on the social rituals of contem-
porary life as the structure for an anachronistic
facade of stately grandeur, Venetian culture pre-
sented two faces: one living for the moment, at-
tempting to capture ephemeral pleasures in pur-
suit of escape; and one tenaciously holding onto
the obsolete traditions of a former way of life.
Tiepolo's bittersweet illustration of this decadent,
jovial scene succeeds precisely because he is able
to capture and work within this sense of division.

– J.H.

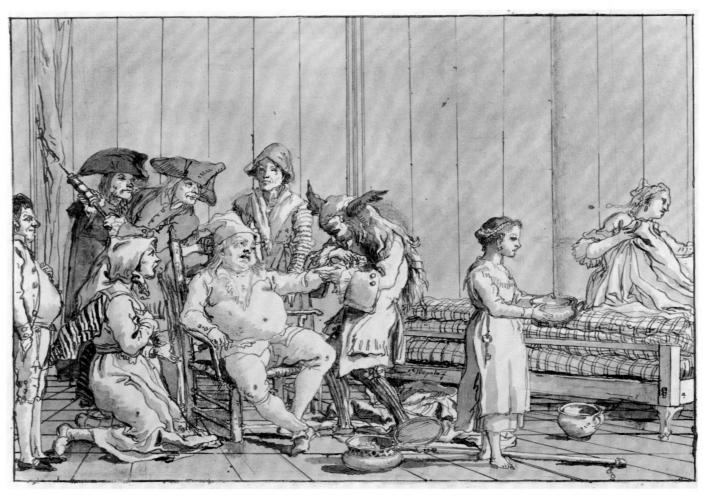

40.

40. Giovanni Domenico Tiepolo
Italy, 1727–1804
Quack Doctors Attend a Stout Man in Harlequin Costume
Pen, brown ink, and gray brown wash with stumped black chalk over black chalk sketch
34.9 × 47.7 cm
The Art Museum, Princeton University, Bequest of Dan Fellows Platt

PROVENANCE: Dan Fellows Platt

LITERATURE: Knox 1964, no. 84; Princeton 1966, no. 103; Princeton 1977, no. 675

This drawing belongs to a series of finished drawings by Domenico known as the *Scenes of Contemporary Life*. The image's references to the *commedia dell'arte* impart to the composition a gently derisive tone. The figure of the doctor, for instance, appears in the Italian stage comedy of the eighteenth century as a laughable and garrulous pedagogue. Prone to lengthy and incomprehensible digressions interspersed with quotations in Latin, his ridiculous character functions as the brunt of mockery directed at the entire scientific community. His bizarre headdress is a reference to the winged cap of Mercury, the patron of physicians and prankster of the Greco-Roman pantheon. Whatever scorn is directed at the figure of the doctor, the bulk of the scene's satire is reserved for the figure of his patient. Probably belonging to Venice's merchant class, his ample proportions distinguish him as a man of at least some wealth. His disheveled appearance in ill-fitting Harlequin costume designates him as a buffoon, while his being attended by the quack physician adds a note of pathos to his predicament. The scatological associations created by the abundance of chamber pots in the right foreground—their presence most likely due to the patient's unnamed malady—add an earthy dimension to the scene's humor which is characteristic of the *commedia dell'arte*.

– C.U.

VARJ CAPRICCJ

Inventati, ed Incisi

DAL CELEBRE GIO. BATTISTA TIEPOLO

novamente Pubblicati,

E DEDICATI

al Nobile Signore

L' ILL:^{mo} S. GIROLAMO MANFRIN

MDCCLXXXV

41.

Vari Capricci

41. G. del Pian
 Italy, eighteenth century
 Title page from the series of etchings *Vari Capricci*
 by Giovanni Battista Tiepolo, published 1785
 Engraving
 11.3 × 16.4 cm
 Fine Arts Museums of San Francisco, Achenbach
 Foundation for Graphic Arts

 PROVENANCE: Unidentified collector's mark;
 KFF von Nagler (1770–1846), Berlin (Lugt 2529);
 Kupferstichkabinett der Staatliche Museen, Berlin
 (Lugt 1606)

 LITERATURE: Rizzi 84, fig. XXVII

Comprising ten etchings by Giambattista Tiepolo,
the *Vari Capricci* were first published in the 1740s
by Anton Maria Zanetti. Zanetti, a publisher, pa-
tron, collector, and amateur printmaker (who, inci-
dentally, was responsible for publishing Gaetano
Zompini's engravings, cat. nos. 11 and 12), inserted
Tiepolo's ten etchings into volumes containing
his collection of chiaroscuro woodcuts. As a result
of this miscellany of works, a title page was not
provided when the *Vari Capricci* were published
in the 1740s. The final edition of the series, pub-
lished posthumously by Tiepolo's son Domenico
in 1785 and dedicated to the illustrious Venetian
patron and collector Gerolamo Manfrin, includes
this framed title page designed by Del Pian.
The process of engraving both the frame and
the letters by hand on a copperplate, as exempli-
fied here, came into favor by the end of the six-
teenth century. By the eighteenth century, Venice
was regarded as Europe's leading center of book
production, especially illustrated books.

– Y.Y.

42. Giovanni Battista Tiepolo
Italy, 1696–1770
Young Man Seated, Leaning against an Urn, plate 1
from *Vari Capricci*, published 1785
Etching
14.3 × 18.1 cm
Dr. and Mrs. Werner Z. Hirsch

LITERATURE: De Vesme 3; Rizzi 29

This work is the first of a series of ten etchings
entitled the *Vari Capricci* (Various caprices). The
capriccio in seventeenth- and eighteenth-century
Venice was a popular genre in which artists gave
free rein to their imagination, mixing the fanciful
with the serious to create unique works of art. As
a genre, the *capriccio* found expression in paint-
ing, drawing, and printmaking. By midcareer,
Giambattista, then known chiefly as a history
painter, employed the medium of etching as an
outlet for further artistic experimentation. Some
scholars have argued that Giambattista's use of
this reproductive medium in the *Capricci* was part
of a broader etching revival.

The dates of the etchings continue to be a sub-
ject of scholarly debate, including whether or not
the *Vari Capricci* were executed before or after the
Scherzi di fantasia, Giambattista's other print se-
ries. While it may be impossible to know when
Tiepolo produced these etchings, there is at least
some evidence suggesting when they were pub-
lished. Anton Maria Zanetti is believed to have
published the series twice, together with his own
works, first in 1743 and again in 1749. The third
and last edition of the series was published posthu-
mously by Giambattista's son Domenico in 1785,
with the addition of a title page (cat. no. 41).

In this print the central figure is a seated youth
leaning against a classical funerary urn and gaz-
ing out at the viewer. Tiepolo presents us with
a cast of characters and props that will be repre-
sented time and again throughout the series.
Despite this continuity, the group of prints as a
whole does not constitute a narrative; rather than
illustrating a story, these images seem more like
generally melancholic studies in staging whereby
Tiepolo conducts experiments in composition,
recycling figures and props while altering their
roles and function.
— L.A.L. & D.Z.

43. Giovanni Battista Tiepolo
Italy, 1696–1770
Three Soldiers and a Youth, plate 2 from
Vari Capricci, published 1785
Etching
14.1 × 17.5 cm
Dr. and Mrs. Werner Z. Hirsch

LITERATURE: De Vesme 4; Rizzi 30

This print from the *Vari Capricci* series exempli-
fies the influence of other artists on Giambattista's
work. Tiepolo's etchings reveal his familiarity with
and debt to the great printmakers of the seven-
teenth century such as Rembrandt from the North
and the Italians Stefano della Bella, Salvator Rosa,
and Castiglione. He had the opportunity to study
these artists' prints in 1739 when, at the death of
the heir to one of Venice's finest print collections,
Tiepolo was asked to evaluate the collection. Simi-
lar to the reclining youth in the previous entry, the
reclining boy in this print may have been derived
from the figure of a youth in Rembrandt's etching
Christ Preaching (about 1652). Giambattista
greatly admired Rembrandt and occasionally
adapted some of his figures for his own work.
The configuration of soldiers is another example
of this kind of artistic borrowing. The soldiers
were most likely influenced by Rosa. The focal
point of Giambattista's scene is the standing youth
whose flag creates the apex of the pyramidal com-
position. This figure is decidedly in the manner of
the Venetian artist Piazzetta, an influential con-
temporary of Tiepolo's. The print demonstrates
Tiepolo's repeated use of props within the series;
here the pole lying on the ground, the flag staff,
spear, and cypress anchor and frame the rounded
forms of human figures in the center of the sheet.
Each of these details can be found in other plates
(see cat. nos. 42, 44, and 45).
— L.A.L. & D.Z.

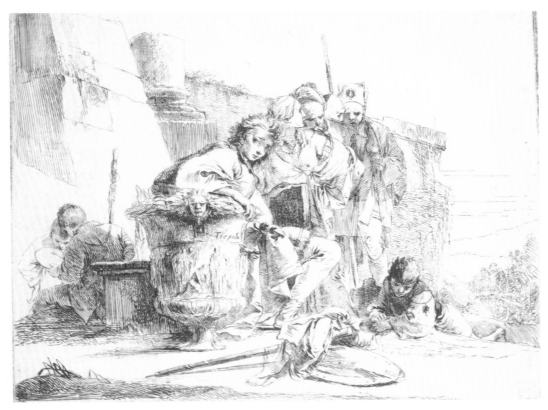

42.

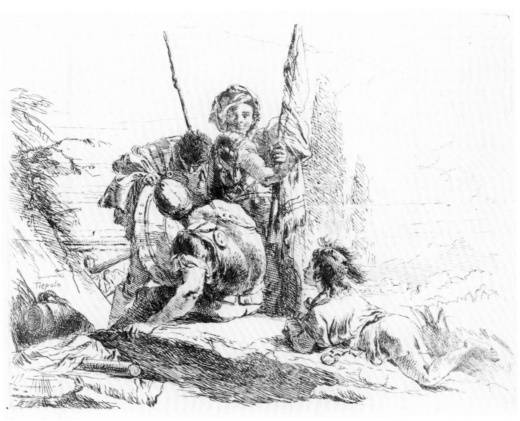

43.

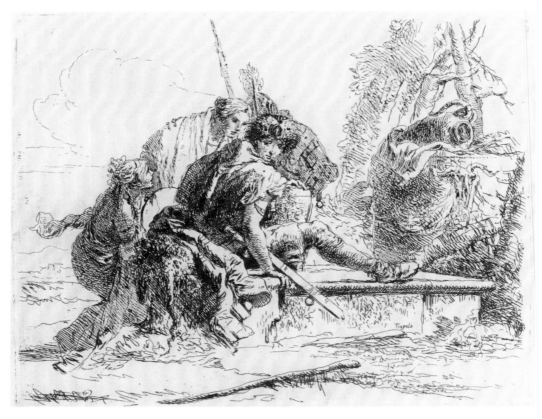

44.

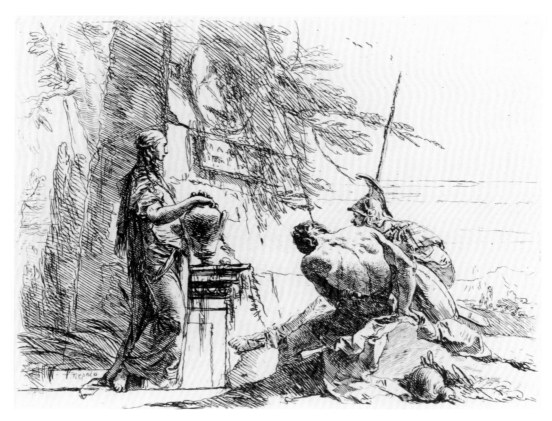

45.

44. Giovanni Battista Tiepolo
 Italy, 1696–1770
 Soldier Seated on a Tomb, plate 3 from
 Vari Capricci, published ca. 1740s
 Etching, second state
 13.3 × 17 cm
 Bernard Jensen, Los Angeles

 PROVENANCE: R. E. Lewis, Inc.

 LITERATURE: De Vesme 5; Rizzi 31

In this print—a particularly fine, early impression from an edition of the *Vari Capricci* published by Count Zanetti in Giambattista's lifetime—Tiepolo again employs a central figure whose engaging glance invites the viewer into the scene. The young warrior sits atop a tomb slab creating a melancholy atmosphere that evokes the theme of the transience of life.

 No one underlying theme is central to the *Vari Capricci*; the figures do not act out narratives or specific events, and there is no evidence to suggest that the images were meant to be arranged in a specific order. What is evident in the *Capricci* is the contemporary interest in antiquity and classical figures, mixed with an eighteenth-century fascination with philosophy and magic that emerged in the Age of Reason, and the timeless subject of human mortality. This scene displays aspects of these interests as well as compositional elements of Giambattista's own invention, such as the almost complete occlusion of one of the figures, as well as the peculiar pose of the seated soldier. A study for the principal figure of this *capriccio* is in the collection of the Victoria and Albert Museum.
 – L.A.L. & D.Z.

45. Giovanni Battista Tiepolo
 Italy, 1696–1770
 Standing Woman and Seated Men before an Obelisk,
 plate 4 from *Vari Capricci*, published 1785
 Etching
 13.7 × 17.3 cm
 Dr. and Mrs. Werner Z. Hirsch

 LITERATURE: De Vesme 6; Rizzi 32

Among the figures included in this etching Tiepolo presents the often-seen Roman soldier. The shirtless man with his back to the viewer reappears in two of the *Scherzi di fantasia* (cat. nos. 58 and 60). Giambattista's consistent and innovative recombination of stock characters such as these and props such as the obelisk and urn demonstrates his ability to generate what seem to be endless variations on a theme.

 The female figure derives in part from Tiepolo's study of Paolo Veronese, an artist championed in eighteenth-century Venice's Enlightenment circles and one who strongly influenced Giambattista's work as a frescoist. Her classical attire is consistent with the environment in which Tiepolo places her; the ruins of an obelisk adorned with a medallion create a quasi-mythological setting similarly found in plates 1 and 2. These figures and set pieces reveal an interest in antiquity, an intellectual passion of the erudite aristocracy of Venice who continued the sixteenth-century tradition of scholarship in archeology, literature, and the arts. Tiepolo's etchings participate in this prevailing eighteenth-century fascination with the heroic virtues of the past, while also containing elements of the mystical and personal, pointing ahead to Goya.
 – L.A.L. & D.Z.

46. Giovanni Battista Tiepolo
 Italy, 1696–1770
 Woman, Satyr Child, and Goat in a Landscape,
 plate 5 from *Vari Capricci*, published 1785
 Etching
 14 × 17.2 cm
 Dr. and Mrs. Werner Z. Hirsch

 LITERATURE: De Vesme 7; Rizzi 33

This idyllic, tranquil scene stands out from among the other *Capricci*; it has often been considered the masterpiece of the series. Its arcadian setting reflects a long-standing Venetian interest in bucolic themes, expressed in both literature and art. In general terms, Giambattista was influenced by pastoral imagery found in etchings by the seventeenth-century Genoese painter, draftsman, and printmaker Giovanni Benedetto Castiglione. For this etching, Tiepolo relied on Stefano della Bella's engraving *Family of Satyrs* (about 1633–39). The central horned goat with the drape across its back is borrowed from the della Bella as are the woman's pose, demeanor, and her loosely draped clothing. Even the tree trunk of the della Bella work is resituated within Tiepolo's image to create the pyramidal design so characteristic of the *Capricci*. Giambattista builds on della Bella's theme and creates for the viewer a pastoral scene offering an intimate glimpse into a mythological world.

– L.A.L. & D.Z.

47. Giovanni Battista Tiepolo
 Italy, 1696–1770
 Standing Philosopher and Two Other Figures,
 plate 6 from *Vari Capricci*, published 1785
 Etching
 13.3 × 17.2 cm
 Dr. and Mrs. Werner Z. Hirsch

 LITERATURE: De Vesme 8; Rizzi 34

In contrast to the bucolic theme found in the previous *capriccio* (plate 5), the melancholy mood of the series is once again evoked in this etching. The figures are surrounded by reminders of death: the stone tomb, funerary urn, and a fallen banner serve to frame an exotic, turbaned sage. The presence of this figure in Venetian art can be traced to Renaissance writers and artists who borrowed from, and Christianized, Eastern rituals and imagery. Tiepolo became aesthetically interested in the sage figure and drew over two hundred studies of him (see for example cat. nos. 15–18). He gave this figure prominence in his etchings of the 1740s under the influence of the Genoese printmaker Castiglione. In the *Capricci* series, the iconography of the sage type is not clearly specified; indeed, the figure in this print is somewhat enigmatic. The sage holds a large book and looks contemplatively into the distance while a soldier and another figure privately converse. Separating these actors is a faintly etched ruin of a sculptural figure, evidence of Tiepolo's fondness for classical sculpture, an interest seldom seen in his etchings but which was often included in his painted works.

– L.A.L. & D.Z.

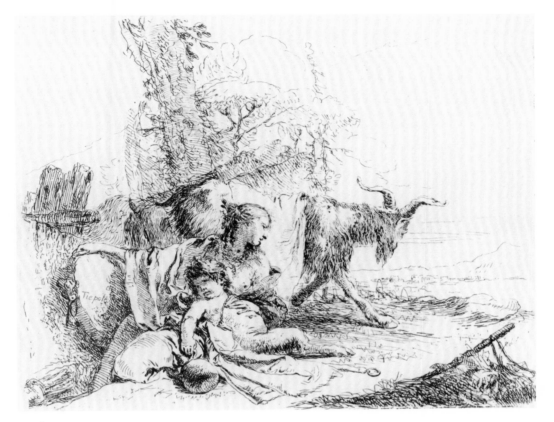

46.

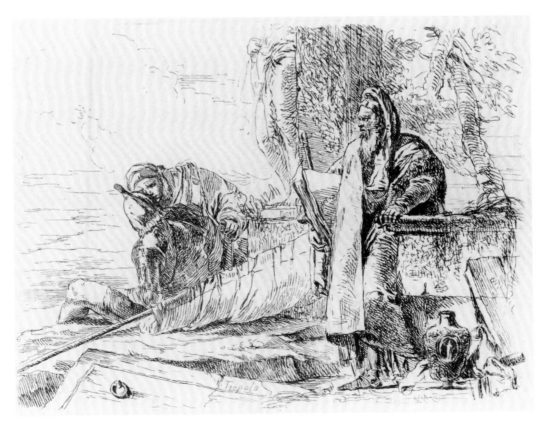

47.

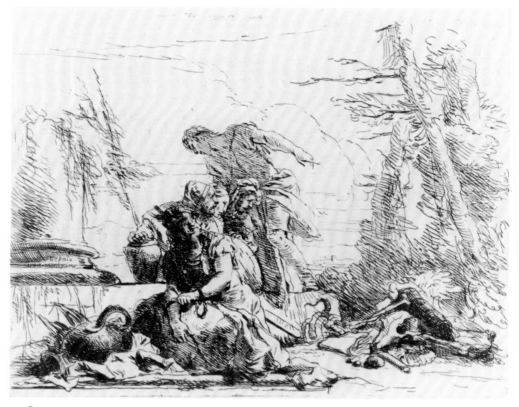

48.

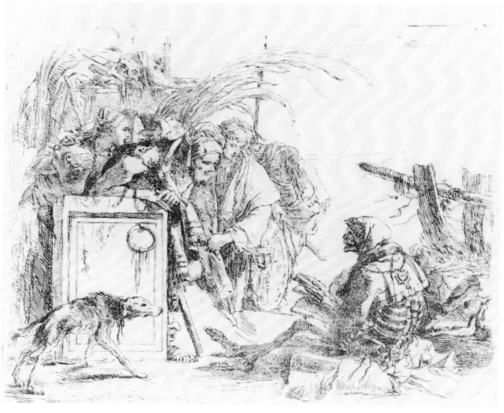

49.

48. Giovanni Battista Tiepolo
 Italy, 1696–1770
 *Women and Men Regarding a Burning Pyre of
 Bones*, plate 7 from *Vari Capricci*, published 1785
 Etching
 13.6 × 17.4 cm
 Dr. and Mrs. Werner Z. Hirsch

 LITERATURE: De Vesme 9; Rizzi 35

This scene echoes the sacrificial fire more fully ex-
plored in the *Scherzi di fantasia* (see, for example,
De Vesme 14, 16, and 20—the latter given here as
cat. no. 58). Here, a mysterious effect is created by
the group of figures transfixed by the burning
pyre of animal bones before them. The standing
figure creates the apex of a compositional triangle
that is vertically framed by trees and a broken col-
umn. Anchoring the triangle is a pile of burning
bones and a darkly shaded urn, next to which is a
seated female figure in chains. The luminous half
shadow enveloping her right side attests to the ar-
tistic influence of Paolo Veronese. Tiepolo used
the chiaroscuro of the great sixteenth-century Ve-
netian painter and colorist to develop the *Capricci*
as a study in contrasts; inked and uninked areas of
paper are used consistently throughout the series.
 – L.A.L. & D.Z.

49. Giovanni Battista Tiepolo
 Italy, 1696–1770
 Death Giving Audience, plate 8 from *Vari Capricci*,
 published 1785
 Etching
 14.1 × 17.9 cm
 Dr. and Mrs. Werner Z. Hirsch

 LITERATURE: De Vesme 10; Rizzi 36

In contrast to the often elusive content of the
Capricci series, in this print the subject of death is
treated with pointed seriousness. In marked oppo-
sition to the pastoral beauty of plate 5 (cat. no. 46),
here a decipherable necromancy is made vivid
through the figure of a hooded skeleton reading
from a book. Characters grouped around a tomb
receive magical communications from the dead,
and an emaciated dog, one of the artist's stock
types, appears, adding to the sense of the macabre.
Drawn by a dog's normal curiosity to this weird
thing, he reminds us of the presence of the every-
day in a scene of the bizarre otherworld.

Four preparatory drawings for this print can be
found in the collection of the Victoria and Albert
Museum, evidence that even when using stock
figures in his prints Tiepolo carefully orchestrated
details of his rich and elaborate compositions. The
spontaneity and freedom with which Tiepolo han-
dled the subject in these preparatory drawings con-
trasts with the meticulous etching, which displays
the rich chiaroscuro prevalent in the finished
series.
 – L.A.L. & D.Z.

50. Giovanni Battista Tiepolo
 Italy, 1696–1770
 Young Soldier with Philosopher, and Seated Woman,
 plate 9 from *Vari Capricci*, published 1785
 Etching
 13.3 × 17 cm
 Dr. and Mrs. Werner Z. Hirsch

 LITERATURE: De Vesme 11; Rizzi 37

In this print, Tiepolo unites references to antiquity with elements of sorcery, a combination he also used in plate 6 (cat. no. 47) from the *Capricci*. The seated woman is classically robed, while the young soldier holds a shield bearing Medusa's head, his Roman helmet placed on a tomb. In the right foreground, the serpent, a symbol of magical knowledge, winds itself around a stick. Behind the soldier, Tiepolo represents one of his favorite actors, the sage, with his long beard and exotic turban. The sage engages the other figures with incantations from his large book. Tiepolo reintroduces these three characters in later works, and they play a narrative role in two paintings of 1750 that are based on the story of Rinaldo and Armida taken from the sixteenth-century poet Tasso's *Gerusalemme liberata*. Tiepolo's etching itself proved inspirational to Antonio Guardi, who created the painting *Minerva* based on this print.

The *Capricci*'s repeated encounters with youth and age go beyond allegory and show the artist's interest in contrasting themes of life and death, of innocence and mystical wisdom, while aesthetically interweaving these themes with recurring motifs, iconography, and compositions.

 – L.A.L. & D.Z.

51. Giovanni Battista Tiepolo
 Italy, 1696–1770
 The Rider Standing beside His Horse, plate 10 from
 Vari Capricci, published 1785
 Etching
 13.9 × 16.4 cm
 Fine Arts Museums of San Francisco, Achenbach
 Foundation for Graphic Arts, 1963.30.295

 LITERATURE: De Vesme 12; Rizzi 38

Marked by dramatic tension, this image speaks to the theatrical sense of gesture characterizing much of eighteenth-century Venetian art. Gripping a dagger, the cavalier who has just dismounted his horse is posed for confrontation. His attendant's wan expression, the dog barking at his feet, and the horse's precarious footing also convey a sense of imminent danger. With the figures directly placed in the foreground—which has also been enlarged to edge out the details of landscape and thus the sense of setting that characterizes the rest of the *Capricci* scenes—the viewer has immediate access to the drama, which is played out as if on a stage. A preparatory drawing for this etching is in the Victoria and Albert Museum.

 – Y.Y.

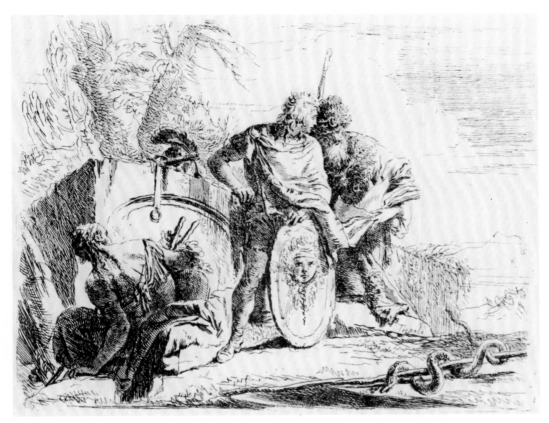

50.

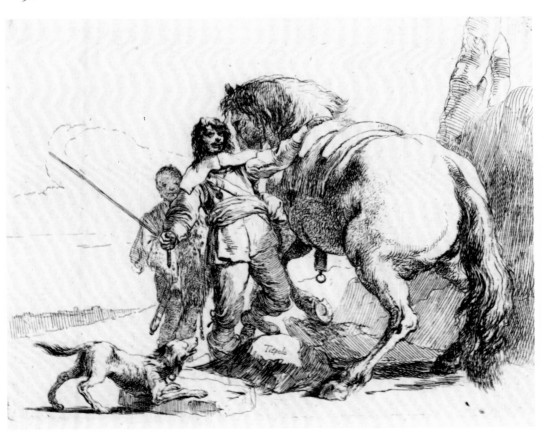

51.

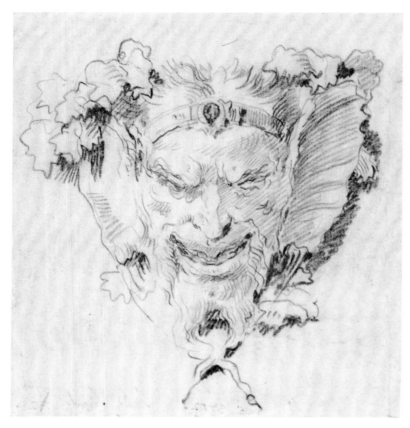

52.

Masking and the Scherzi: A Theater of the Mind

52. After Giovanni Battista Tiepolo
Italy, 1696–1770
Satyr's Head
Red and white chalk
13.8 × 12.9 cm
Museum of Fine Arts, Boston, Gift of
Edward Habich, 1895

PROVENANCE: Bossi; Beyerlen; Eisenmann;
Habich

LITERATURE: Sack 1910, p. 250, no. 89, as
Giambattista; Knox 1980, p. 224, M. 124, as
Giambattista; Boston 1983, p. 68, no. 73

This drawing, formerly thought to be from Giambattista's own hand, is now believed to be the work of a copyist. Nevertheless, the composition and subject are typically those of the master. Although the head is human, it bears a savage grin. Framed by unfurling leaflike ears and decorative leaves, the head is mounted for close observation. *Satyr's Head* resembles the sculptural masks Tiepolo includes in his print series the *Scherzi di fantasia*. In the *Magician and Other Figures before a Burning Altar* (cat. no. 58), for example, two satyrs' heads serve as decorative reliefs on the prominent altar, symbols of a bacchanalian antiquity.

The delight eighteenth-century Venetian culture took in the exotic and grotesque may be seen as symptomatic of a society consumed with spectacular facades and costumed appearances. Beyond reversing human identities and roles, Carnevale rituals often involved appropriating aspects of the animal or the marginal, the foreign or the enigmatic, allowing for a more potent range of escape from social mores and hierarchies. Tiepolo's famed genius for invention involved a mixture of fact and fancy, established form and improvisation, tapping into those in-between areas of definition and categorization where imagination could take flight.

– J.H.

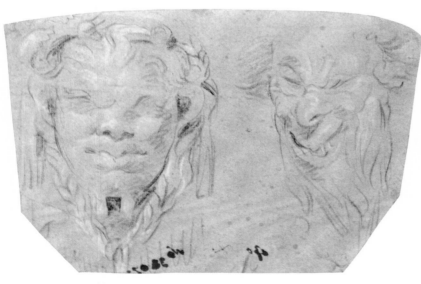

53.

53. Giovanni Battista Tiepolo or
Giovanni Domenico Tiepolo
Italy, 1696–1770 or 1727–1804
Heads of Two Fauns
Black chalk, heightened with white, on pale gray
paper
12.7 × 17.5 cm (irregular)
Museum of Fine Arts, Boston, Gift of
Edward Habich, 1895

PROVENANCE: Bossi; Beyerlen; Eisenmann;
Habich

LITERATURE: Sack 1910, p. 250, no. 85, as
Giovanni Battista Tiepolo; Knox 1980, p. 244,
M. 120, as Domenico; Boston 1983, pp. 69–70,
no. 76

This study of two fauns' heads, executed with
vibrant spontaneity in black chalk, offers us a
glimpse into Giambattista's experiments with the
theatrical and the grotesque. The two heads, re-
sembling masks that may have been worn at Car-
nevale, display extraordinary yet indefinable emo-
tional expressions. The juxtaposition of the faun
on the right, with his garish smile and exagger-
ated nose, with the more serious faun on the left,
with his protruding lips and flattened nose, brings
to mind the popular pair of dramatic masks sym-
bolizing tragedy and comedy in the theater and
suggest again the way in which the theater and
Tiepolo's work embodied the notion of emotional
types, types that may have been based in classical
mythology, in contrasts such as the Apollonian
and the Dionysiac. These two masklike heads
demonstrate Tiepolo's ability to treat related
subjects in varied and imaginative ways.

– D. Z.

hats and voluminous cloak, so conducive to dis-
guise, evoke the secretive and fantastic side of
eighteenth-century Venice pervasive during the
period of Carnevale. The images also point to
Tiepolo's interest in costume—itself a form of
artful disguise—and gesture. At once playful and
disconcerting, the identities of the men are con-
cealed, and the masks are offered in place of their
faces. Tiepolo's varied washes add interest to this
study.

– C.U.

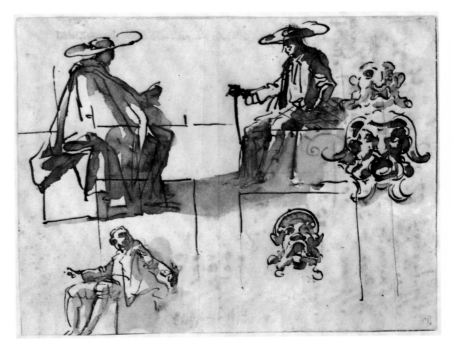

54.

54. Giovanni Battista Tiepolo
Italy, 1696–1770
*Three Seated Male Figures and Three Sculptured
Fantastic Masks*
Pen, brown ink, and gray brown wash
13.4 × 17.2 cm
The Art Museum, Princeton University, Gift of
Frank Jewett Mather, Jr.

PROVENANCE: Frank Jewett Mather, Jr.

LITERATURE: Roerich 1930, no. 58; Knox 1964,
no. 52; Princeton 1977, no. 584

This peculiar study of three seated figures and
three sculptured masks provides an intimate look
into Tiepolo's private—that is to say, uncommis-
sioned—production. The figures and masks sug-
gest an improvisational way of working. Hori-
zontal and vertical lines that intersect the figures
enframe the bottom mask. The broad-brimmed

55. Giovanni Battista Tiepolo
Italy, 1696–1770
*Half-Dressed Nymph with Two Children,
Surrounded by Four Men*, from *Scherzi di fantasia*,
published ca. 1735–58
Etching
22.1 × 17.6 cm
Fine Arts Museums of San Francisco, Achenbach
Foundation for Graphic Arts purchase, 1965.68.8

PROVENANCE: Collection Alianello (Lugt 5K);
Gerda Bassenge, Berlin

LITERATURE: De Vesme 15; Rizzi 6i/ii

56. Giovanni Battista Tiepolo
Italy, 1696–1770
*Seated Magician Regarding Animal Skulls,
and Other Figures*, from *Scherzi di fantasia*,
published ca. 1735–58
Etching
22.5 × 17.8 cm
Dr. and Mrs. Werner Z. Hirsch

LITERATURE: De Vesme 16; Rizzi 8

57. Giovanni Battista Tiepolo
Italy, 1696–1770
Seated Magician with Other Figures beside an Altar,
from *Scherzi di fantasia*, published ca. 1735–58
Etching
21.8 × 17.8 cm
Dr. and Mrs. Werner Z. Hirsch

LITERATURE: De Vesme 18; Rizzi 9

58. Giovanni Battista Tiepolo
Italy, 1696–1770
*Magician and Other Figures before a Burning Altar
with Skull and Bones*, from *Scherzi di fantasia*,
published ca. 1735–58
Etching
23 × 17.2 cm
Dr. and Mrs. Werner Z. Hirsch

LITERATURE: De Vesme 20; Rizzi 11

Elements of theatricality and artifice dominate
cat. no. 55. Replete with trademark Tiepolo picto-
rial props, such as the polelike forms of the tree
trunks, halberds, and a snake-wound staff, the im-
age actively engages the viewer. Tiepolo also de-
pends on a cast composed entirely of characters of
the type we have already seen in the single dressed
figures (a nymph, a soldier, a satyr-child) and
other props such as turbans, shields, swords, urns,
and amulets, collectively functioning as a kind of
orientalizing set decoration. Most compelling is

the way in which the various faces, be they animal
or human, deflect our attention to another object
or person so that our eye roves constantly over the
surface of the image. In effect, Tiepolo arranges
the figures as if on a stage: clustered in the middle
pictorial zone, they form a viewing barricade, sup-
pressing any spatial depth and thus the viewer's
penetration through the stage door.

Most of the *Scherzi* compositions include a
sage-type figure (in cat. nos. 56, 57, and 58, he is
a magician either seated or standing next to an
altar) surrounded by various other figures—youth-
ful or aged, nude or costumed—in an enigmatic
setting containing ancient ruins, snakes, and piled
up bones. Each etching, reassembling the same
motifs in innovative ways to create different im-
ages of equally rich visual detail and pictorial fasci-
nation, demonstrates Tiepolo's versatility as an art-
ist. This trio of images, which again cannot be
placed in a definitive order within the series, rein-
forces the notion that the *Scherzi* are variations on
a theme; they speak compellingly of Tiepolo's in-
ventive prowess. In each case, the stately, elderly,
bearded magician wearing a slightly modified cos-
tume consisting of a billowing cloak with trim, a
headpiece, and, in most cases, an amulet, stands as
the central figure.

Tiepolo's interest in sorcery and the occult sci-
ences made him an inheritor of the pictorial leg-
acy of the seventeenth-century artists Salvator
Rosa and Giovanni Benedetto Castiglione, both
of whom depicted the magical and fantastical in
their work. It has been suggested that the repre-
sentation of Eastern sages and mystical rites re-
flects a desire to escape the conservative social
mores and traditional power of the Catholic
Church during Tiepolo's time, as well as docu-
menting Venice's status as a city with a door
open to the Near East.

– Y.Y.

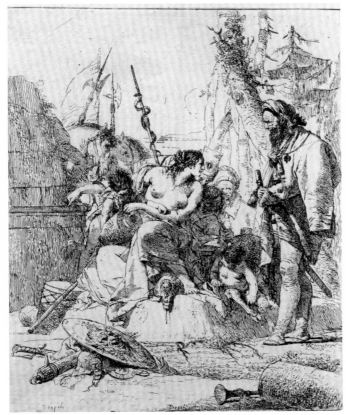

55.

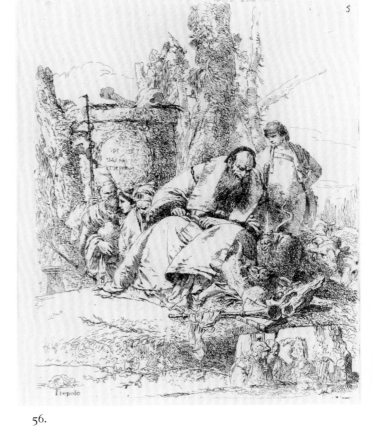

56.

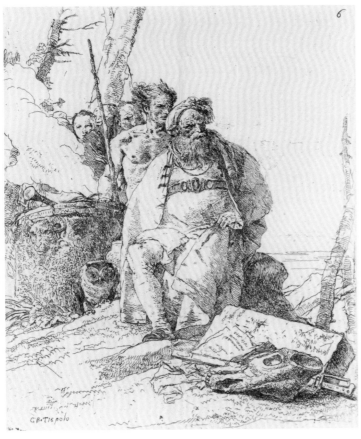

57.

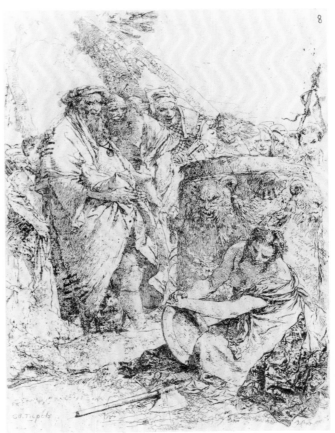

58.

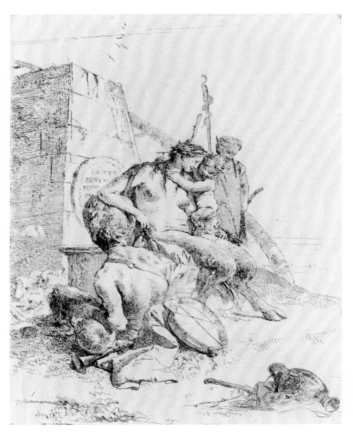

59.

59. Giovanni Battista Tiepolo
Italy, 1696–1770
Satyrs with Obelisk at Left, from *Scherzi di fantasia*,
published ca. 1735–58
Etching
22.6 × 17.6 cm
Dr. and Mrs. Werner Z. Hirsch

LITERATURE: De Vesme 23; Rizzi 14

Seated in front of an obelisk and diagonally
flanked by two male satyrs, the female satyr and
her child are arranged in a classic Madonna-and-
Child pose. The motif is adapted, however, to a
theme of fantasy derived from classical mythol-
ogy. Even here, Tiepolo redefines the satyr type
of antiquity to include female satyrs. As can be
expected with Tiepolo, the reclining male satyr
with his back to us is a masculine rephrasing of
the seated mother satyr. The musical instruments,
combined with the obelisk and water jug, evoke
the bucolic and pastoral. Even the tree trunk is
strategically arched to create the pastoral illusion
of a rainbow.

The arcadian vision is a convention of fantasy
with roots in Renaissance literature. It recurs
throughout the *Scherzi*, and its appearance in the
etching medium supports two popular concep-
tions of eighteenth-century Venice: first, that the
city experienced a "second Renaissance" in the vi-
sual arts, and second, that it fostered an etching
revival supported by a small class of collectors
and connoisseurs. By allowing artists to conjure
semiprivate worlds of poetic fantasy in a small,
intimate format without the demands of patron-
age, etching was the voice through which their
imagination—stimulated by an emphasis on
artifice and illusion—found expression.

– Y.Y.

60. Giovanni Battista Tiepolo
Italy, 1696–1770
Two Seated Magicians and Two Youths,
from *Scherzi di fantasia*,
published ca. 1735–58
Etching
22.5 × 17.5 cm
Dr. and Mrs. Werner Z. Hirsch

LITERATURE: De Vesme 26; Rizzi 17

The subjects of the *Scherzi di fantasia* are at once
fanciful and ominous. Both time and circum-
stance within the prints are ambiguous, as are
Tiepolo's motivations and his designs of the fig-
ures. These complex compositions offer a visual
challenge to unravel the multiplicity of hidden
meanings and associations. Here the two magi-
cians, figures alluding to both wisdom and mystery,
appear to be instructing the youths, one of whom
carries a book while the other reclines against a
globe half sunk into the earth. The presence of
the compass and sphere indicates that the matter
of their inquiry is celestial. While the youths ap-
pear untroubled and attentive to their tutors, the
magicians' faces express an unsettling air of malev-
olence. This tension is amplified by the reiteration
of the magicians' features in the animals' faces
and in the masks hidden within pottery and ruins.
A particular correspondence can be seen between
the central magician and the goat to his right, as
well as with the visage on the urn the magician
holds with his left arm. This visual correspon-
dence suggests the bestial and inhuman nature
of the sorcerers. The staff entwined with a snake
which the sage holds may be an allusion to the
Old Testament magicians who challenged Moses
in his negotiations with Pharaoh. The staff is
also associated with the caduceus of Mercury, the
trickster and herald of the Greco-Roman gods.

– C.U.

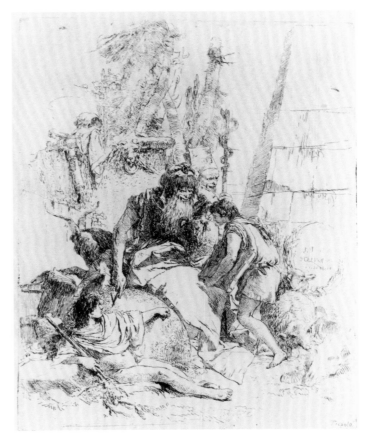

60.

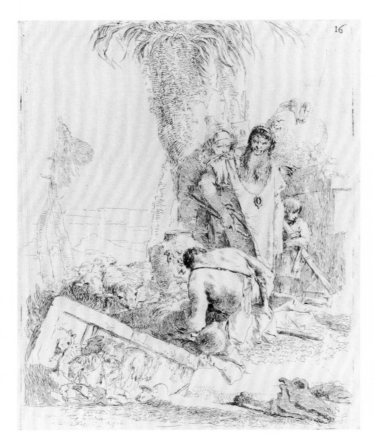

16

61.

61. Giovanni Battista Tiepolo

Italy, 1696–1770

Seated Man and Two Magicians, from *Scherzi di fantasia*, published ca. 1735–58

Etching

22.5 × 17.5 cm

Dr. and Mrs. Werner Z. Hirsch

LITERATURE: De Vesme 28; Rizzi 19

The figures of the two magicians appear throughout the *Scherzi di fantasia* series. Often engaged in pursuits related to the observation of the heavenly spheres—here their attendant carries a telescope—and other natural phenomena and accompanied by references to the Greco-Roman past, they appear to represent the wisdom of the ancient pagans. Visual reminders of classical antiquity are evident in the fragment of a Hellenistic frieze buried in the foreground as well as in the urns flanking the sages; these vases are embellished with masks that mimic the physiognomies of the magicians, linking them further with the pagan past.

The subjects of the *Scherzi* series are fraught with ambiguity and a sense of transience. We are unable to place the events depicted within a temporal framework, as the simultaneous presence of so many disparate references creates a sense of disembodied and illusory time. The recurring *memento mori* motif of scattered bones and architectural ruins conveys a sense of decadence and putrefaction. One senses an intangible evil in the sinister faces of the magicians and the desolate landscape they inhabit. This effect is heightened by the attitude of the man they have encountered, crouched as he is before them. One wonders if the sorcerers are merely bystanders amid this devastation, or if they have been its cause, an effect that is far removed from the pagan wisdom to which they also refer. The relationship between wisdom, the illogical or magical, and decay is one of the mysteries surrounding the *Scherzi* yet to be fully deciphered.

– C.U.

62. Giovanni Battista Tiepolo

Italy, 1696–1770
Two Magicians and a Boy, from *Scherzi di fantasia*,
published ca. 1735–58
Etching
14.1 × 18.9 cm
University of California, Berkeley Art Museum,
purchase made possible by a bequest from
Therese Bonney, Class of 1916, 1996.9

PROVENANCE: R. E. Lewis, Inc.

LITERATURE: De Vesme 34; Rizzi 25i (of ii)

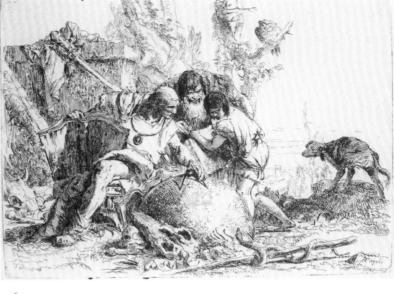

62.

The figures of the two magicians and the attending
youth gaze intently at the sphere at the center
of the composition. Armed with books and
mathematical instruments, they appear to have
struck on some discovery. However, their triumph
is marred by signs of decay and the evil portents
lurking about them. The presence of an owl in the
tree at the right helps to shed light on the signifi-
cance of the group. At once a symbol of wisdom
and evil, the owl was associated with Athena and
embodied the knowledge of the ancient Greeks.
At the same time, it was feared as a fierce, rapa-
cious predator prowling the night sky. The conver-
gence of wisdom and evil or, as in catalogue num-
ber 61, wisdom and decay seems to be central to
Giambattista's personal cosmology in these uncom-
missioned works, and it is tempting to equate it to
the moment of simultaneous renaissance and ruin
in contemporary Venetian culture. The sword at
the left of the group also casts an ominous tone
over the scene: as the hilt rests against the ruins of
a wall, the point disappears into the back of one of
the sorcerers. As a whole, the scene articulates a
sense of the sterility and falseness of knowledge,
described here in pagan terms, in the face of mor-
tality. This sense of barrenness is reinforced by the
presence of a discarded staff in the foreground,
a common motif in Tiepolo's printmaking.

– C.U.

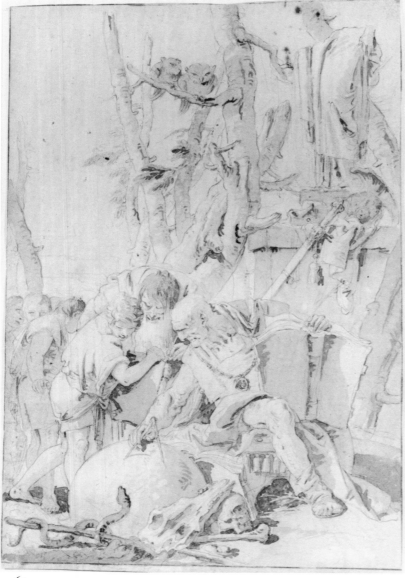

63.

63. Giovanni Battista Tiepolo
Italy, 1696–1770
Democritus and Heraclitus Laughing and Sorrowing over the Follies of the World, from *Scherzi di fantasia*, published ca. 1735–58
Black chalk, pen and brown ink, brown wash
40.2 × 27.4 cm
Peter Jay Sharp Collection, courtesy National Academy of Design, New York

PROVENANCE: Artaria, Vienna; Gottfried Eissler, Vienna; private collection, Switzerland

LITERATURE: Sack 1910, pl. 294, as G. B. Tiepolo; Pignatti 1965, under no. 34; Pignatti 1970, p. 308; Udine 1970, no. 23; Rizzi 1971, fig. 25; Knox 1972, p. 842, as Francesco Lorenzi, after G. B. Tiepolo; Victoria and Albert 1975, p. 63, as Francesco Lorenzi; Morassi 1975, p. 88; Knox 1994, pl. 16, as G. B. Tiepolo; National Academy 1994, pl. 28

This drawing, whose title is traditional, is related to one of Tiepolo's etchings from the *Scherzi di fantasia* series exhibited here, *Two Magicians and a Boy* (cat. no. 62), one of the earliest of the *Scherzi*. The two works resemble each other insofar as both feature the same three central figures huddled around a sphere. Other objects found in both images include the sages' books, the compass, the horse's skull, and the snake coiled around the stick. The drawing, however, contains an upper area that does not appear in the print. The finished quality of the drawing suggests that it is not a preparatory study for the etching but rather a work in its own right, one that may have evolved simultaneously alongside the creation of the *scherzo*. A number of studies for Tiepolo's etchings in London's Victoria and Albert Museum do not appear as clearly finished as this large drawing; they are experimental studies executed swiftly, without the attention to detail found in this work. Juxtaposing this drawing with the *Scherzi* print provides an ideal opportunity for the viewer to compare and contrast Tiepolo's style in two different media.

 –D.Z.

64. Giuseppe Bernardino Bison

Italy, 1762–1844
Scene of Antique Sacrifice
Pen and brown ink, brush with brown and pink
wash, over traces of black chalk
23.1 × 34.7 cm
The Metropolitan Museum of Art, Rogers Fund,
1970. (1970.177)

LITERATURE: London 1970, no. 46;
Metropolitan 1971, p. 115, under no. 297;
Metropolitan 1990, p. 32, no. 11

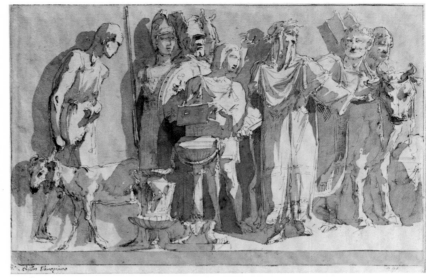

64.

A virtuoso draftsman, Bison largely established
his reputation through his landscape *capricci*, or
fantasies, but he also produced views of Venice,
set designs, architectural studies, interior designs,
and floral pieces, as well as mythological and reli-
gious scenes in his graphic work. In this drawing,
Bison's frenetic line and heavily laid washes delin-
eate a neoclassical scene of ritual sacrifice. The
characters are distinguished by theatrical elements
alone: costume, gesture, and facial expression
determine each individual's role, for Bison's con-
cern lies more in explicating the scene than in-
timately searching for the identity of each charac-
ter. The composition itself takes its model from
the theater: resembling an ancient relief, the hori-
zontal staging of the figures, their manner of ges-
ture, and the positioning of their faces present a
rich tableau accessible to the viewer. It is interest-
ing to note the presence of the same characters
found in Giambattista Tiepolo's print series:
the sage, the youth, and the Roman soldier.

– J.H.

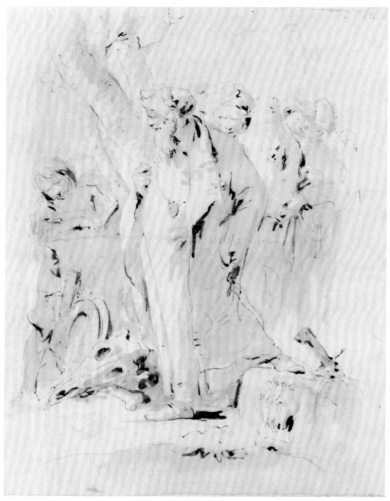

65.

65. Giovanni Battista Tiepolo

Italy, 1696–1770
Three Figures Examining a Skull, ca. 1735–40
Pen and sepia wash on ivory laid paper
22 × 16.8 cm
Philadelphia Museum of Art: The John S. Phillips
Collection, acquired with the Edgar V. Seeler
fund (by exchange) and with funds contributed by
Muriel and Philip Berman, 1984-56-91

PROVENANCE: Pennsylvania Academy of the
Fine Arts

LITERATURE: PAFA 1974; Pignatti 1974;
Philadelphia 1988

Tiepolo produced several drawings that relate to
his series of etchings, the *Vari Capricci* and the
Scherzi di fantasia. Three Figures Examining a Skull
was never directly transferred to a plate for the
print series, but in this wash drawing we find sev-
eral elements common to other studies and the
print series. The magician at the center is reminis-
cent of the many *sole figure vestite* of which we
know Tiepolo drew hundreds, an important type
for many of the *Scherzi* plates. The horse's skull
can also be seen in other scenes from the *Scherzi* in-
cluded in this exhibition (see for example cat. no.
57). Tiepolo's versatility manifested itself in the
way he could repeatedly use a stock set of charac-
ters and props and present them in new and var-
ied forms in all the various media in which he
worked.

–D. Z.

66. Giovanni Battista Tiepolo

Italy, 1696–1770
Three Figures and an Owl, 1730s
Pen and sepia wash over black chalk
22.2 × 16.7 cm
Philadelphia Museum of Art: The John S. Phillips
Collection, acquired with the Edgar V. Seeler
fund (by exchange) and with funds contributed by
Muriel and Philip Berman, 1984-56-92

PROVENANCE: Pennsylvania Academy of the
Fine Arts

LITERATURE: Cambridge 1970, no. 17; PAFA
1974; Birmingham 1978

Several drawings by Tiepolo relate indirectly to
his celebrated series of etchings the *Scherzi di fanta-
sia*. According to George Knox, evidence suggests
that Tiepolo derived some of the content and char-
acters found in his print series from drawings
such as this one, which he created in the 1730s.
Though not a preparatory study for any particular
print, Tiepolo once again presents us with his
familiar cast of characters: the owl, which appears
time and again in the *Scherzi* etchings (in over
half of the twenty-three prints in the series), the
bearded sage wearing a turban, the woman, and
the young boy. The funerary urn decorated with a
masklike head, recalling the masks of catalogue
numbers 52 and 54, is also one of Tiepolo's favor-
ite props. Despite the similarities in content and
related evocations of youth, wisdom, and the an-
tique, the different media afforded Tiepolo the op-
portunity to exercise his versatility. The hurried
strokes and spontaneous execution of this drawing
contrast with the more careful preparation involved
in etching.

– D.Z.

66.

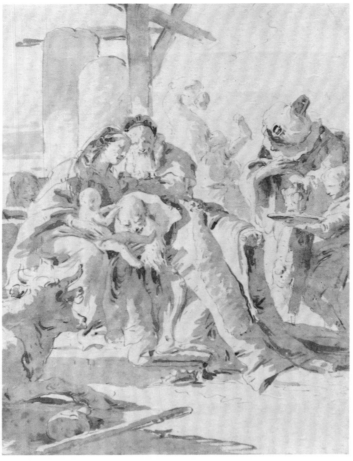

67.

67. Giovanni Battista Tiepolo
Italy, 1696–1770
Adoration of the Magi, ca. 1753
Pen and brown ink and brown wash over black
chalk on laid paper
40.4 × 29.4 cm
Fine Arts Museums of San Francisco, Gift of Mrs.
Charles Templeton Crocker to the San Francisco
Museum of Modern Art, on long-term loan to the
Achenbach Foundation for Graphic Arts

PROVENANCE: Mrs. Charles Templeton Crocker
(later Mrs. Paul Fagan)

LITERATURE: Berkeley 1968, no. 60; Cam-
bridge 1970, no. 21; Washington 1972, no. 21;
Los Angeles 1976, no. 62

68. Giovanni Battista Tiepolo
Italy, 1696–1770
The Adoration of the Magi, from *Scherzi di fantasia*,
published ca. 1740
Etching
41 × 28.7 cm
Fine Arts Museums of San Francisco, Achenbach
Foundation for Graphic Arts, 1963.30.300

LITERATURE: De Vesme I; Rizzi 27

This drawing (cat. no. 67) of the Adoration of
the Magi is one of four related works on which
Tiepolo based one of his most ambitious etchings,
included here. Yet according to Lorenz Eitner
(Stanford 1993, pp. 138, 140), the drawings can-
not be placed in a chronological relationship to
the finished etching. Instead, they illustrate Tie-
polo's practice of returning to the same theme,
reworking motifs, and discovering new combina-
tions. Further, the fact that the final etching does
not read as a mirror image of the drawing, as
would normally be the case if this drawing had
been prepared for transfer to a metal plate, sug-
gests a looser relationship between the two
works.

Still, the relationship is a close one. The dra-
matic pose of the turbaned figure bowing in rever-
ence remains the same, while the Holy Mother
and the servant boy are slightly modified. In the
etching, Mary's position is less protective. Both em-
ploy settings that rely on columns and wooden
beams as backdrops, yet each work produces a dif-
ferent effect on the viewer in part due to the differ-
ent media—the fluidity of wash and the precision
of the etched line. The drawing, through its unify-
ing tonal washes, its emphasis on the figures and
their costumes, and the close-up angle offered the
viewer, creates an intimate atmosphere that more
readily absorbs the viewer into the foreground
as a participant. In contrast, the etching is self-
contained and theatrical, putting the viewer at a
distance. The figures are enclosed within a land-
scape of broken reliefs, enigmatic medallions, ex-
otic figures, and urns bearing masklike medal-
lions. The infant Jesus is presented more for the
admiration of the viewer and less for that of the
wise men. The winged cherubs in the sky rein-
force the strong grounding of the figures. The
etching technique facilitates the inclusion of
meticulous details.

Tiepolo frequently reworked time-honored reli-
gious subjects such as the Adoration of the Magi,
yet for the most part this imagery has not found a
place in the present exhibition. The sustained in-
fluence of the Catholic Church, still clearly a domi-
nant force in Tiepolo's Venice and one that strictly
controlled individual behavior outside of Carne-
vale, suggests the importance of this work to the
artist's oeuvre. Yet these two Adorations can also
be related to Tiepolo's taste for the theatrical, for
stock-in-trade devices that may find their origins
in social practice (for example, the *commedia*)
but that then undergo the transformation of the
artist's personal vision.

– Y.Y. & J.C.S.

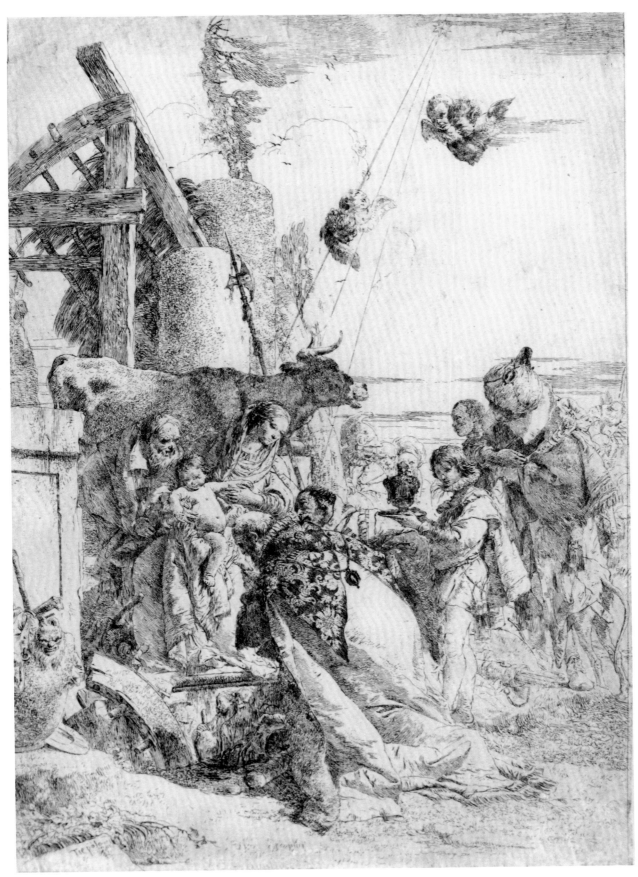

68.

Select Bibliography

Short references are supplied for those sources used in the notes to the essays and the Literature sections of the entries. Catalogue raisonné numbers of the prints refer to De Vesme 1906 and Rizzi 1971.

Allen Memorial Art Museum, Oberlin, Ohio. *Exhibition of Master Drawings of the Eighteenth Century in France and Italy*. Exhibition catalogue. 1951.

Alpers, Svetlana, and Michael Baxandall. *Tiepolo and the Pictorial Intelligence*. New Haven, Conn.: Yale University Press, 1994.

The Art Institute of Chicago. *Loan Exhibition of Paintings, Drawings, and Prints by the Two Tiepolos: Giambattista and Giandomenico*. Exhibition catalogue by D. Catton Rich. 1938.

The Art Institute of Chicago. *Italian Drawings in the Art Institute of Chicago*. Catalogue by Harold Joachim and Suzanne Folds McCullagh. 1979.

ART JOURNAL 1971–72 "College Museum Notes: Acquisitions." *Art Journal* 31 (1971–72): 439.

BENESCH 1947 Benesch, Otto. *Venetian Drawings of the Eighteenth Century in America*. New York: H. Bittner & Co., 1947.

BERKELEY 1968 Berkeley, Calif., University Art Museum. *Master Drawings from California Collections*. Exhibition catalogue edited by J. Schulz. 1968.

BIRMINGHAM 1958 Birmingham, Ala., Birmingham Museum of Art. *Exhibition of Italian Art*. Exhibition catalogue. 1958.

BIRMINGHAM 1978 Birmingham, Ala., Birmingham Museum of Art. *The Tiepolos: Painters to Princes and Prelates*. Exhibition catalogue edited by E. Weeks. 1978.

BLOOMINGTON 1979 Bloomington, Indiana University Art Museum. *Domenico Tiepolo's Punchinello Drawings*. Exhibition catalogue edited by Marcia E. Vetrocq and Adelheid M. Gealt. 1979.

Boston, Museum of Fine Arts. *Master Drawings of Venice*. Exhibition catalogue. 1958.

BOSTON 1983 Boston, Museum of Fine Arts. *Italian Drawings in the Museum of Fine Arts, Boston*. Catalogue by Hugh Macandrew. 1983.

Buffalo Fine Arts Academy, Buffalo. *Master Drawings Selected from the Museums and Private Collections of America*. Exhibition catalogue by Agnes Mongan. 1935.

Byam Shaw, James. "The Drawings of F. Fontebasso." *Arte Veneta* 8 (1954): 320–25.

BYAM SHAW 1962 Byam Shaw, James.

The Drawings of Domenico Tiepolo. London: Faber & Faber, 1962.

Byam Shaw, James. "Some Venetian Draughtsmen of the Eighteenth Century." *Old Master Drawings* 7 (1933): 47–63. Reprinted in *James Byam Shaw: Selected Writings*. London, 1968, pp. 70–85.

BYAM SHAW 1970 Byam Shaw, James. "The Biron Collection of Venetian Eighteenth-Century Drawings in the Metropolitan Museum." *Metropolitan Museum Journal* 3 (1970 [1971]): 235–58.

Cambridge, Mass., Fogg Art Museum. *One Hundred Master Drawings*. Catalogue by Agnes Mongan. 1949.

CAMBRIDGE 1970 Cambridge, Mass., Fogg Art Museum. *Tiepolo: A Bicentenary Exhibition, 1770–1970: Drawings, Mainly from American Collections, by Giambattista Tiepolo and the Members of His Circle*. Exhibition catalogue by George Knox. 1970.

CA' REZZONICO 1937 Ca' Rezzonico, Venice. *Le feste e le maschere veneziane*. Exhibition catalogue by Giulio Lorenzetti. Venice: C. Ferrais, 1937.

CONNOISSEUR 1959 "Drawings from the Paul Wallraf Collection." *Connoisseur* 144 (1959): 238–39.

Daniel, Howard. *The Commedia dell'arte and Jacques Callot*. Sydney, Australia: Wentworth Press, 1965.

The Detroit Institute of Arts and Indianapolis, John Herron Art Museum. *Venice, 1700–1800*. Exhibition catalogue. 1952.

DE VESME 1906 De Vesme, A. *Le Peintre-graveur italien: ouvrage faisant suite au Peintre-graveur de Bartsch*. Milan: Hoepli, 1906.

GEALT 1985 Gealt, Adelheid M. *Giovanni Domenico Tiepolo: The Punchinello Drawings*. New York: Georges Braziller, 1985.

GORIZIA 1985 Castello di Gorizia. *Giambattista Tiepolo: il segno e l'enigma*. Exhibition catalogue by Dario Succi. Ponzano: Vianello Libri/Foligraf, 1985.

HASKELL 1980 Haskell, Francis. *Patrons and Painters: Art and Society in Baroque Italy*. 1963. 2d ed. New Haven, Conn., and London: Yale University Press, 1980.

International Exhibitions Foundation, Washington, D.C. *Venetian Drawings from American Collections*. Exhibition catalogue by Terisio Pignatti. 1974.

IOWA CITY 1964 Iowa City, University of Iowa, School of Fine Arts. *Drawing and the Human Figure, 1400–1964*. 1964.

Joe and Emily Lowe Art Gallery, Coral Gables, Fla., University of Miami. *The Samuel H. Kress Collection: A Catalog of European Paintings and Sculpture*. Exhibition catalogue by Fern Rusk Shapley. 1961.

JONARD 1965 Jonard, Norbert. *La Vie quotidienne à Venise au XVIIIe siècle*. Paris: Hachette, 1965.

KNOX 1964 Knox, George. "Drawings by Giambattista and Domenico Tiepolo at Princeton." *Record of the Art Museum, Princeton University* 1 (1964): 2.

KNOX 1972 Knox, George. "G. B. Tiepolo: The Dating of the *Scherzi di Fantasia* and the *Capricci*." *Burlington Magazine* 119 (December 1972): 837–42.

KNOX 1980 Knox, George. *Giambattista and Domenico Tiepolo: A Study and Catalogue Raisonné of the Chalk Drawings*. Oxford: Clarendon Press, 1980.

KNOX 1983 Knox, George. "Domenico Tiepolo's Punchinello Drawings: Satire, or Labor of Love?" In *Satire in the Eighteenth Century*, edited by J. D. Browning, pp. 124–46. New York: Garland Publishing, 1983.

KNOX 1984 Knox, George. "The Punchinello Drawings of Giambattista Tiepolo." In *Interpretazioni veneziani: studi di storia dell'arte in onore di Michelangelo Muraro*, edited by David Rosand, pp. 439–46. (Venice: Arsenale, 1984).

KNOX 1994 Knox, George. "Francesco Guardi in the Studio of Giambattista Tiepolo." In *Atti . . . Guardi*. Forthcoming.

KRESS 1956 Samuel H. Kress Foundation. *Paintings and Sculpture from the Kress Collection Acquired by the Samuel H. Kress Foundation, 1951–1956*. Exhibition catalogue. Washington, D.C.: National Gallery of Art, 1956.

KRESS 1973 Samuel H. Kress Foundation. *Paintings from the Samuel H. Kress Collection: Italian Schools*. Catalogue by Fern Rusk Shapley. London: Phaidon Press, 1973.

Levey, Michael. *Giambattista Tiepolo: His Life and Art*. New Haven, Conn.: Yale University Press, 1986.

LEVEY 1994 Levey, Michael. *Painting in Eighteenth-Century Venice*. 3d. ed. New Haven, Conn., and London: Yale University Press, 1994.

LONDON 1970 London, Colnaghi's. *Old-Master and English Drawings*. Exhibition catalogue. 1970.

LONDON AND WASHINGTON 1994 London, Royal Academy of Arts, and Washington, National Gallery of Art. *The Glory of Venice: Art in the Eighteenth Century*. Exhibition catalogue by Jane Martineau and Andrew Robison. New Haven, Conn.: Yale University Press, 1994.

LOS ANGELES 1976 Los Angeles County Museum of Art. *Old-Master Drawings from American Collections*. Exhibition catalogue by E. Feinblatt. 1976.

LOUISVILLE 1990 Louisville, Ky., The J. B. Speed Art Museum. *The Mask of Comedy: The Art of Italian Commedia*. Exhibition catalogue by Eleonora Luciano. 1990.

Magrini, Marina. *Francesco Fontebasso*. Vicenza: N. Pozza, 1988.

Magrini, Marina. "Francesco Fontebasso: i desegni." *Saggi e Memorie di Storia dell'Arte* 17 (1990): 163–211.

Mariuz, Adriano. *Giandomenico Tiepolo*. Venice: Alfieri, 1971.

Mariuz, Adriano. "The Drawings of Domenico Tiepolo." In *Masterpieces of Eighteenth-Century Venetian Drawing*, edited by E. Goldschmidt. New York: Thames and Hudson, 1983.

The Metropolitan Museum of Art, New York. *Tiepolo and His Contemporaries*. Exhibition catalogue by H. B. Wehle. 1938.

METROPOLITAN 1971 New York, The Metropolitan Museum of Art. *Drawings from New York Collections III. The Eighteenth Century in Italy*. Catalogue by Felice Stampfle. 1971.

The Metropolitan Museum of Art, New York. *The Robert Lehman Collection, VI: Italian Eighteenth-Century Drawings*. Catalogue by James Byam Shaw and George Knox. Princeton, N.J.: Princeton University Press, 1987.

METROPOLITAN 1990 New York, The Metropolitan Museum of Art. *Eighteenth-Century Italian Drawings in the Metropolitan Museum of Art*. Catalogue by Jacob Bean and W. Griswold. 1990.

Mills College Art Gallery, Oakland, Calif., and California Palace of the Legion of Honor, San Francisco. *Venetian Drawings, 1600–1800*. Exhibition catalogue by Alfred Neumeyer. 1960.

Morassi, Antonio. *Tiepolo*. Bergamo, Milan, and Rome: Istituto italiano d'arti grafiche, 1943.

Morassi, Antonio. *G. B. Tiepolo: His Life and Work*. London: Phaidon Press, 1955.

MORASSI 1959 Morassi, Antonio. *Disegni veneti del settecento nella collezione Paul Wallraf*. Venice: N. Pozza, 1959.

Morassi, Antonio. *A Complete Catalogue of the Paintings of G. B. Tiepolo*. London: Phaidon Press, 1962.

MORASSI 1975 Morassi, Antonio. *Guardi: Tutti i disegni di Antonio, Francesco e Giacomo Guardi*. Venice: Alfieri, 1975.

Museo Correr, Venice, and Palazzo Attems, Gorizia. *Da Carlevarijs ai Tiepolo: Incisioni veneti e friuliani del Settecento*. Exhibition catalogue by Dario Succi. 1983.

NATIONAL ACADEMY 1994 New York, National Academy of Design. *European Master Drawings from the Collection of Peter Jay Sharp*. Exhibition catalogue. 1994.

National Gallery, London. *The Eighteenth-Century Italian Schools*. Catalogue by Michael Levey. 1956.

NEWBERRY 1955–56 Newberry, J. S., Jr. "A Punchinello Drawing by Domenico Tiepolo." *Bulletin of the Detroit Institute of Arts* 35, no. 4 (1955–56): 92–94.

PAFA 1974 Philadelphia, Pennsylvania Academy of the Fine Arts. *Old-Master Drawings from the Academy Collections*. Exhibition catalogue. 1974.

Palazzo Grassi, Venice. *Pietro Longhi, Gabriele Bella: Scene di vita veneziana*. Exhibition catalogue by Giorgio Busetto. Milan: Bompiano, 1995.

PALLUCCHINI 1976 Pallucchini, Rodolfo. "Per un'attribuzione al Fontebasso." *Paragone*, nos. 312–19 (1976): 172–79.

Pedrocco, Filippo. *Disegni di Giandomenico Tiepolo*. Milan, 1990.

PHILADELPHIA 1988 Philadelphia Museum of Art. *Recent Acquisitions*. 1988.

The Pierpont Morgan Library, New York. *Drawings from the Lore and Rudolf Heinemann Collection*. Exhibition catalogue edited by Felice Stampfle and Cara D. Denison. 1973.

The Pierpont Morgan Library, New York. *Drawings from the Collection of Mr. and Mrs. Eugene V. Thaw*. Exhibition catalogue by Felice Stampfle and Cara D. Denison. 1975.

PIGNATTI 1965 Pignatti, Terisio. *I disegni veneziani del settecento*. Treviso: Canova, 1965.

Pignatti, Terisio. *Le acqueforti dei Tiepolo*. Florence: La Nuova Italia, 1965.

PIGNATTI 1970 Pignatti, Terisio. *I disegni dei maestri. La scuola veneta*. Milan, 1970.

PIGNATTI 1974 Pignatti, Terisio. *L'opera completa di Pietro Longhi*. Milan: Rizzoli, 1974.

POMONA 1976 Pomona, Calif., Montgomery Art Gallery, Pomona College. *Eighteenth-Century Drawings from California Collections*. Exhibition catalogue. 1976.

PRINCETON 1966 The Art Museum, Princeton University. *Italian Drawings in the Art Museum: 106 Selected Examples*. Catalogue by Jacob Bean. 1966.

PRINCETON 1977 The Art Museum, Princeton University. *Catalogue of Italian Drawings in the Art Museum, Princeton University*. Catalogue by Felton Gibbons. 2 vols., 1977.

Ridotto, Venice. *Mostra degli incisori veneti del settecento*. Exhibition catalogue by Rodolfo Pallucchini. Venice: Libreria serenissima, 1941.

RIZZI 1971 Rizzi, Aldo. *The Etchings of the Tiepolos: Complete Edition*. London: Phaidon Press, 1971.

ROERICH 1930 New York, Roerich Museum. *Exhibition of Drawings by Old Masters from the Private Collection of Professor Frank Jewett Mather, Jr.* Exhibition catalogue. 1930.

SACK 1910 Sack, E. *Giambattista, Giandomenico Tiepolo: Ihr Leben und ihre Werke*. 2 vols. Hamburg: Clarmann, 1910.

SANTA BARBARA 1964 Santa Barbara, Calif., Santa Barbara Museum of Art. *European Drawings, 1450–1900*. Exhibition catalogue. 1964.

SANTA BARBARA 1976 Santa Barbara, Calif., Santa Barbara Museum of Art. *European Drawings in the Collection of the Santa Barbara Museum of Art*. Exhibition catalogue. 1976.

SANTIFALLER 1976 Santifaller, Maria. "In margine alle ricerche Tiepolesche. un ritrattista Germanico di Francesco Algarotti: Georg Friedrich Schmidt." *Arte Veneta* 30 (1976): 204–9.

SEATTLE 1974 Seattle, Wash., Henry Art Gallery, University of Washington. *Eighteenth-Century Venice*. Exhibition catalogue. 1974.

STANFORD 1941 Stanford, Calif., Stanford Art Gallery. *The Mortimer C. Leventritt Collection of Far Eastern and European Art*. Exhibition catalogue. 1941.

STANFORD 1973 Stanford, Calif., Stanford Art Gallery. *The Arts of Venice in the Eighteenth Century*. Exhibition catalogue. 1973.

STANFORD 1980 Stanford, Calif., Stanford Art Gallery. *Eighteenth-Century Italian Prints from the Collection of Mr. and Mrs. Marcus S. Sopher with Additions from the Stanford University Museum of Art*. Exhibition catalogue by Claudia Lazzaro. 1980.

STANFORD 1981 Stanford, Calif., Stanford Art Gallery. *Master Drawings*. Exhibition catalogue. 1981.

STANFORD 1982 Stanford, Calif., Stanford Art Gallery. *Venice in the Eighteenth Century*. Exhibition catalogue. 1982.

STANFORD 1993 Stanford, Calif., Stanford University Museum of Art. *Stanford University Museum of Art: The Drawing Collections*. Catalogue by Lorenz Eitner, Betsy G. Fryberger, and Carol M. Osborne. 1993.

Tunick, David. *Italian Prints of the Eighteenth Century: The Illustrated Bartsch, XI*. New York: Abaris Books, 1981.

Udine, Loggia del Lionello. *Disegni del Tiepolo*. Exhibition catalogue by Aldo Rizzi. Udine: Tip. Doretti, 1965.

UDINE 1970 Udine, Loggia del Lionello. *Le acqueforti dei Tiepolo*. Exhibition catalogue by Aldo Rizzi. Milan: Electa Editrice, 1970.

University Art Museum, Santa Barbara, Calif. *Old-Master Drawings from the Feitelson Collection*. Exhibition catalogue edited by Alfred Moir. 1983.

VAN SCHAACK 1962 van Schaack, Eric. *Master Drawings in Private Collections*. New York: Lambert-Spector, 1962.

VICTORIA AND ALBERT 1975 London, Victoria and Albert Museum. *Catalogue of the Tiepolo Drawings in the Victoria and Albert Museum*. Catalogue by George Knox. 1975.

VIGNI 1972 Vigni, Giorgio. *Disegni del Tiepolo*. Trieste: La Editoriale Libraria, 1972.

Washington, D.C., National Gallery of Art. *Tiepolo Drawings from the Victoria and Albert Museum, London*. Exhibition catalogue by Graham Reynolds. 1961.

WASHINGTON 1968 Washington, D.C., National Gallery of Art. *European Paintings and Sculpture*. 1968.

WASHINGTON 1972 Washington, D.C., National Gallery of Art. *Rare Etchings by Giovanni Battista and Giovanni Domenico Tiepolo*. Exhibition catalogue by H. Diane Russell. 1972.

WASHINGTON 1975 Washington, D.C., National Gallery of Art. *European Paintings: An Illustrated Summary Catalogue*. 1975.

Washington, D.C., National Gallery of Art. *Jacques Callot Prints and Related Drawings*. Exhibition catalogue by H. Diane Russell. 1975.

Washington, D.C., National Gallery of Art. *Master Drawings from the Collection of the National Gallery of Art and Promised Gifts*. Exhibition catalogue by Andrew Robison. 1978.

WASHINGTON 1979 Washington, D.C., National Gallery of Art. *National Gallery of Art, Washington: Catalogue of Italian Paintings*. Catalogue by Fern Rusk Shapley. 2 vols. 1979.

WASHINGTON 1985 Washington, D.C., National Gallery of Art. *European Paintings: An Illustrated Catalogue*. 1985.

Zompini, Gaetano. *Le arti che vanno per via nella città di Venezia*. Venice: Filippi, 1968.